IMAGES
of America
AZUSA

IMAGES
of America

AZUSA

Jeffrey Lawrence Cornejo Jr.

ARCADIA
PUBLISHING

Published by Arcadia Publishing
Charleston SC, Chicago IL, Portsmouth NH, San Francisco CA

Printed in the United States of America

Library of Congress Catalog Card Number: 2006933892

For all general information contact Arcadia Publishing at:
Telephone 843-853-2070
Fax 843-853-0044
E-mail sales@arcadiapublishing.com
For customer service and orders:
Toll-Free 1-888-313-2665

Visit us on the Internet at www.arcadiapublishing.com

I dedicate this book to all Azusans—past, present, and future.

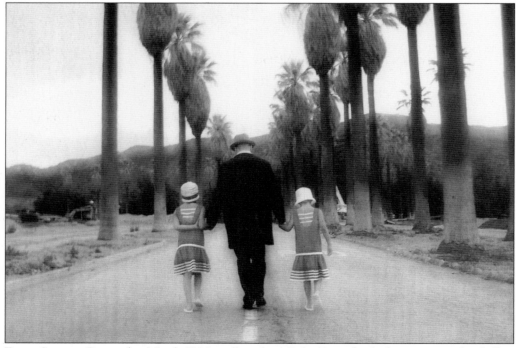

FINAL STROLL. Pictured in March 2006 strolling down Palm Drive for the last time is author Jeffrey Lawrence Cornejo Jr. with nieces Jessica Rose Martinez (left) and Desiree Monique Martinez.

CONTENTS

ACKNOWLEDGMENTS

Many people generously contributed photographs and information to make this book possible, including city clerk Vera Mendoza, the late Adolph A. Solis, Phyllis Vosburg Shattuck, Kathy Lewis, John Phelps, the late Evangeline Noriega Warner, Grace Ruelas Ayon, the late Wes Kloepfer, George Pieper, Ken Otto of Azusa Pacific University, Azusa Pacific University Archives, Sayre Macneil, Bradford Macneil, Francisca Newman, Monrovia Growers, the late Lillian V. Trujillo, the Azusa Historical Society Archives, Azusa Chamber of Commerce, G. W. Davis Photography, Cornelius Smith Photography, Donell Spencer, Rumsey Photography, the late Jack E. Williams, C. W. Tucker, E. H. Gray, William Harota, Don and Shirley Clark, Carmelita Castillo, Alfred and Lucille Pedroza, MacDonald Photography, C. B. Long, and C. L. Hickson Studio.

In addition, I'd like to thank the following individuals for helping throughout the process and providing me with the support to make this all possible, including the board of directors of the Azusa Historical Society; Amy Miller; Miles R. Rosedale; Elizabeth Ramirez; Tracy Lee Williams; my aunt Rebecca Barajas; my very dear friend who helped make this all possible, Ana Maria Mukanos; my best bub, David A. McMurray; my grandparents Virginia Louise and Jesse Cornejo; Auntie Monie; Aunt Monica; my sister Melissa and brother Raymond; my nieces Jessica and Desiree and nephew Raymond Jr.; my mother, Roxanne; my father, Jeff; Nana Ramona, who gave me and trusted me with my first historic pictures; and my late grandfather Alexander Alvarado Rubio, who always reminded me that "One can't know where one is going if one doesn't know from where he came."

INTRODUCTION

The first recorded reference to Azusa was found in the diary of Fr. Juan Crespi, a Franciscan diarist and engineer with the Portola Expedition of 1769, on his way to explore Monterey Bay. During his expedition, Father Crespi wrote about the river and the valley, describing the topography of the land thusly: "The valley is three leagues wide and paralleled by a tall mountain range running east and west." As was the Spanish explorers' custom, Crespi named the stream and valley after the patron saint of the day, San Miguel Archangel, but he also referred to it in his diary as "El Susa." The land was home to the Asuksa-nga, a Shoshonean Native American tribe locally known as the Gabrielenos by the white emigrants and homesteaders who settled in the area. It is believed that the name "Azusa" is a derivative of the Native American name.

The first distinct record of the Rancho Azusa appears on August 14, 1841, when a Mexican trader, Don Luis Arenas, petitioned the *ayuntamiento*, or town council, of Los Angeles for a league of land to the west of the Rancho San Jose Addition. Arenas came into possession of the 4,500-acre Mexican land grant called Rancho Azusa on April 26, 1842. Its boundaries were defined on the west by Citrus Avenue, on the east by the San Gabriel River, on the north by Sierra, and on the south by San Jose, also known as the San Bernardino Road. Soon after taking possession, Arenas constructed a dirt *zanja*, or ditch, from the mouth of the San Gabriel Canyon of the San Gabriel River to his homestead located in the portion of his land south of Foothill Boulevard and east of Cerritos Avenue. He later extended the zanja in a southerly and southeasterly direction, using the water for irrigation, livestock, and his home.

On December 24, 1844, Arenas sold his holdings, which included one-third interest in the Rancho San Jose Addition, the entire Rancho Azusa, 700 head of cattle, and farming implements to the Englishman Henry Dalton for $7,000. Dalton, a prosperous landowner and merchant, had earned his wealth by buying and shipping goods from Peru to Wilmington Harbor (in today's Port of Los Angeles) and San Francisco. Dalton moved to California in 1843 and lived in Los Angeles with the dream of one day owning his own ranch. When the sale was completed, Dalton changed the name of the rancho to Rancho Azusa de Dalton and moved to the homestead in 1846. Throughout the next several years, he acquired lands to the west of the San Gabriel River, in what are now the cities of Duarte and Monrovia.

Between 1844 and 1846, Dalton acquired one third of the Rancho San Jose Addition, which today makes up the cities of Claremont, Pomona, San Dimas, La Verne, and Glendora. In 1846, Dalton purchased another 800 acres of the San Francisquito, which today is the city of Irwindale. In 1847, he bought the Rancho Santa Anita, now known as the city of Arcadia. That same year, on July 14, he married Maria Guadalupe Zamorano, the daughter of a lieutenant colonel in the Mexican Army and a descendant of one of the oldest and most prominent families of the South. According to the assessment roll of 1851, Dalton owned a total of 45,280 acres, making him one of the largest landholders of the San Gabriel Valley.

During Dalton's ownership, he experimented with planting a vineyard that extended northward from his hilltop residence to the Sierra, the range that became known as the San Gabriel Mountains.

He raised cattle, grew citrus fruit, pears, and tobacco, and developed the property into a thriving agricultural enterprise with various outbuildings including a granary, distillery, a vinegar house, a meat smokehouse, winery, stables, and flour mill. The flour mill was located along an irrigation ditch that diverted water to the southern portion of his ranch. The millstones were imported from France in 1854 and were used frequently by members of the community who brought their grain to Dalton for grinding after the floods of 1861 and 1862 washed out the flour mills located along the San Bernardino Canyon.

By 1855, the discovery of gold in the San Gabriel Canyon brought new settlers to the valley. With their arrival came water problems for Dalton. Without the use of water, the land occupied by the settlers was of little or no value. Although there was plenty of water in the river for all, Dalton's ditch was entirely too small to carry a sufficient amount to the settlers. He agreed to let the settlers use the water provided that they would enlarge the ditch to a two-head capacity (200 inches). It was enlarged, and for a number of years the settlers enjoyed the privilege of taking water from the Dalton ditch. As the years passed, however, Dalton would become increasingly concerned over how much this usage might adversely affect his water rights, and he consequently refused permission to the settlers to take any more water from his ditch.

As a result, the U.S. Government Land Commission was forced to intervene and sent surveyor Henry Hancock to California to survey Dalton's holdings. The result of his report, created between October and November 1858, was the declaration that 18,500 acres of Dalton's land would be made open to settlers for homesteading as well as most of his water rights. This declaration removed more than half of Dalton's land. News of this decision spread like wildfire as squatters took possession of the land in the disputed boundary areas. They extended the branch zanja in a southerly and southwesterly direction toward Irwindale. This extension would become known as the Squatter's Ditch, after the settlers who built it. After all was said and done, Dalton was allowed to keep 4,500 acres of Rancho Azusa and its water rights. He disputed the government's decision and filed a lawsuit but continued to operate business as usual on the ranch.

As Dalton's money began to be depleted due to attorney's fees, he realized that he would have to begin mortgaging the Rancho Azusa. Between his in- and out-of-court battles, and the failure of his business ventures, he lost most of his capital. One such venture, his Mound City Land and Water Company, failed. Its assets became the property of the Los Angeles County Savings Bank.

Jonathan Sayre Slauson, the founder and manager of the Los Angeles County Savings Bank, had first been introduced to the ranch in 1874 when the bank had examined it for loan purposes. Slauson, who was originally from New York and had moved to the West Coast in 1863, purchased part of the Rancho Azusa in 1880. Although Dalton was no longer owner, in a kind gesture Slauson deeded to him 46 acres of land located at the north end of town where he and his family relocated, moving into the adobe originally constructed in 1842 for the ranch miller. On January 24, 1884, Henry Dalton passed away in Los Angeles with his family at his side. This was the same year that Slauson became sole owner of Rancho Azusa.

In 1886, Slauson sold most of the rancho lands to the Azusa Land and Water Company, an enterprise that he and other investors had created for the purpose of real estate speculation. He retained about 800 acres of the land for his family, giving 250 acres each to his daughters, Kate Slauson Vosburg and Louise Slauson Macneil, as gifts upon their respective marriages.

One

A BIRD'S-EYE VIEW OF AZUSA IN 1887

In 1887, the Azusa Land and Water Company laid out the streets and founded the town of Azusa. In Henry Dalton's honor, a prominent avenue was given his name. It has been reported during the street grading that many Native American relics, such as mortars and pestles, were unearthed. Soon after the sale of lots opened on April 15, 1887, water problems arose once again. To aid with the growing water travails, a new ditch, "the Covina," was constructed and an agreement to share the San Gabriel River water between the communities of Azusa, Covina, and Duarte was established. This agreement stimulated the fledgling agricultural industry in the San Gabriel Valley. Citriculture became the dominant agricultural activity for the region in the 1890s.

During this time, the Azusa Land and Water Company dissolved and the remaining unsold acreage was divided among the stakeholders, with Slauson giving his remaining acreage to his only son, James. Throughout the next few years, the Slauson children, James, Kate, and Louise, would come to acquire and gain control of other properties, the majority being in the northeastern part of town. Eventually most of this land was devoted to citrus cultivation. The township of Azusa was integrated as a general law city of the sixth class and incorporated on December 29, 1898, with a population of about 860 residents. Throughout the years, the Dalton family's influence in the growth of Azusa has been recognized in city landmarks. Streets in Azusa and Glendora, as well as a wash, park, and elementary school, bear the Dalton name.

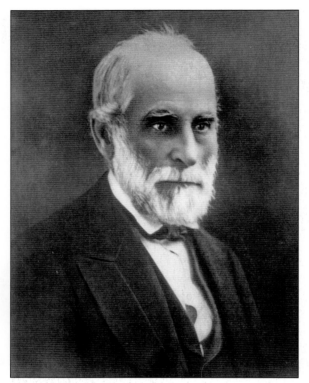

HENRY DALTON. Also known as "Don Enrique," Henry Dalton was born on October 8, 1803, in Limehouse, England, to Winnall Travally Dalton and Ann Woolfe Dalton. At age 17, he became a cabin boy on a ship sailing to South America. Dalton spent the next 20 years in Callao and Lima, Peru, where he would raise his first family. While there, Dalton began to trade with Alta California. In 1843, he moved to California, leaving his Peruvian family behind. On December 24, 1844, Dalton purchased Rancho Azusa from Luis Arenas. He met Maria Guadalupe Zamorano in 1846 and they married on July 14, 1847, at the San Gabriel Mission. Dalton was 43 years old and his bride 15. He went on to own Ranchos Azusa, San Jose, San Francisquito, and Santa Anita. In 1880, his last piece of land went up for auction. Henry Dalton died in Los Angeles at the home of his friend, Frank Sabichi, on January 21, 1884.

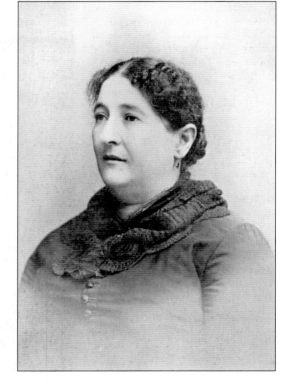

MARIA GUADALUPE ZAMORANO. Born in Monterey, California, on December 18, 1832, Zamorano was the fourth child of Maria Luisa Arguello de Zamorano and Augustin Vicente Zamorano. She met Henry Dalton in 1846 and married him on July 14, 1847, at the age of 15 at the San Gabriel Mission. The couple had 11 children, 7 of whom reached adulthood: Augustin, Luisa, Soyla, Henry Francisco, Elena, Valentine, and Joseph Russell. Maria Guadalupe Zamorano died in Azusa on September 1, 1914.

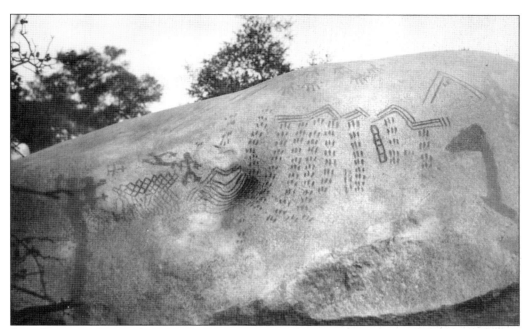

SAN GABRIEL NATIVE AMERICAN ROCK. A huge boulder containing petroglyphs rests on the east bank of the former site of Camp Rincon in the Canyon North Fork. Reports credit the prints as the probable work of the Chemehecui, a Native American tribe said to have roamed in the valley as late as 1845.

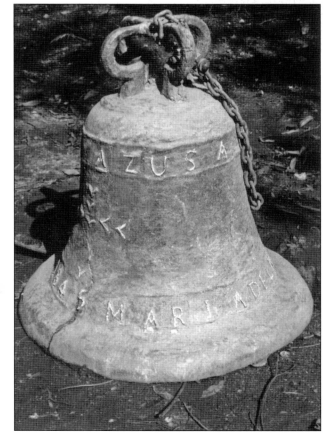

AZUSA BELL. The first bell in Azusa was purchased in the town of San Blas in Mexico and brought here in 1845 by Henry Dalton. Weighing 375 pounds and measuring 24 by 24 inches in diameter, it was used initially to call Dalton's workers in from the far-flung fields of his rancho. Across the top was the word "Azusa," and the inscription below was "Maria de Refugio Años 1845."

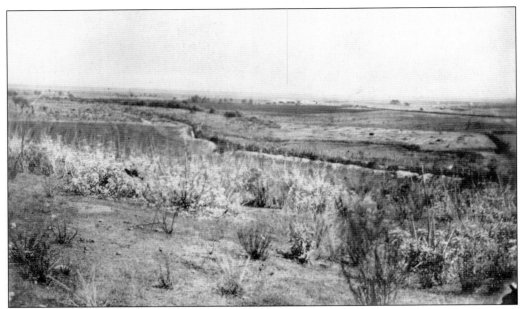

RANCHO AZUSA, C. 1850S. This photograph, looking south from the hill above Ninth Street and Pasadena Avenue, shows Dalton's irrigation ditch.

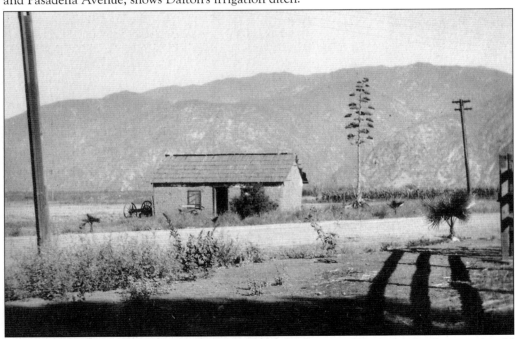

DALTON ADOBE. Located at the intersection of Azusa Avenue and Sierra Madre Avenue, the old adobe house was originally built in 1862 by Henry Dalton as a residence for his miller, Edward Flowers. After being inhabited by Flowers and his family, tenant American and Mexican farmers, who farmed the adjoining lands, lived it in and then by Capt. John T. Gordan, who occupied it as a bee ranch. Later, after Henry Dalton lost his entire land holdings, the Dalton family moved into this crude dwelling, located within 45 acres of surrounding land.

Benton Map, 1851. The first proposed city on this site was one planned by Henry Dalton back in 1851. There were five main east-west thoroughfares: Hope, Spring, Summer, Autumn, and Winter Streets. The two north-south main arteries were Victory and Currant Streets. Unfortunately, when Dalton drew up this plot for the city of Benton, it was before the railroad boom. No nearby rail service existed, and the failure to attract sufficient attention to continue the development meant that Dalton could not raise enough money to put his "city" on the map.

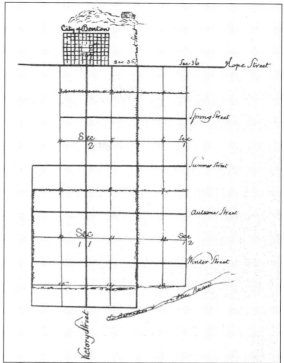

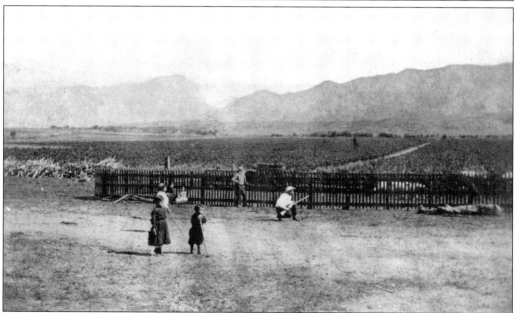

The Dalton Family at Azusa. The family stands amidst the vineyard adjacent to Dalton Hill in this photograph from the 1860s. In the foreground, Valentine Dalton leans on the hoe next to his sister Ellen. Young Henry Dalton is directly behind Ellen and in front of sister Soyla and a friend sitting by fence. Father Henry is to their right, and Winnall (with the hat) prepares to kill a bullock.

AZUSA VALLEY HOMESTEADERS MAP

This map drawn and data compiled

from U.S Land Office Records,

May 30, 1937 by Ernest Robertson

J.T. GORDON

JEROME MADDEN 80

JAS YATES 1875 165

SIERIA MADRE AVE.

M H LA FETR
TIMBE

LA FETRA 1890
80 CHAST

A B HAWAR
70 Geo Bu

Preston School

J.C. PRE 1891

FOOT

JOHN CAS 1865

J.N. SMT 1869

BAS

W.J. DeSM
MAR 2518

AZUSA RANCHO

CITRUS AVE

OCUTTOG AVE

JORDAN SHULTIS

CHAS YOST 1884

4 BROADWAY

5

S. VILSON 887

NELSON WILLIAMSON 1881

ARCHIBALD THOMPSON 1890

ANN ELIZ SCOTT 1882

ELISA P.

JESSE

NEWTON DUTCHER 1886

80 ACRES LARKIN BARNES 1981

LARKIN BARNES 1881

ANSON PITCHER

JUSTICE 1874

JUSTICE 1874

HALVORTO BAIJALRE 1881

SRRR SK JONES 1886

Jo
BO

BONITA AVE.

40 80 80 80 80 80

40

AYLOR 1877

JACOB KINMERLY 1882

JOHN R ORTIZ 1884

G. FRANO 80 1886
G FRANO 80

JEAN S JENNITTE

1.

4.

MATIE 1877

IRE S. THOMPSON 1874

J NINNO 1881

G. W. BOHANON 1880 40

Wm FORBES 1885

LUCY BOHANON 1885

LUY BOHANON

JOHN PRESLEY BOHANON

COLEMAN BARNES

MARY CHILSON 1890

R
ANG
40
R
N

BAUGHMAN

8 9 80 10 40 11 40 40 40

AUSTINE AVE

JOHN REED 1859

JOHN DODSON 1874

TRUJILLO

E R THOMPSON

ELDRIDGE THOMPSON 1872

JOHN SHELTON 1877

VOLNEY PURDY 1885

SRRR ALFRED E MARSHALL 1885

CHAS P SHOREY

CL

ESS AVE
FE SELLS 1881

SHAFFER AVE

VINCENT AVE

MARY ELLEN

40 40 80 80 J.W.MARSHALL 40 40

JAMES REED 1874

H.B.S. DAVIS 1883

M.A.HUMPHREY 1877

E.R. THOMPSON

ELIZABETH BRYANT 1885

SAM BAUME 1875

G YAUGHN 1880

CHAS. P. 1877

80 80 40 80 80

TAYLINDALE

ORONGA AVE

JESSE SEARS 1882

PLACIDO RUELIAS 1881

G. AGUATA 1885

MARIAN MILLER 1882

R.J. POLLARD 1881

MORTON WAKEFIE 1885

74 42 81

SAN BERNARDINO ROAD

77 16 15 14

PHILLIP SHORES TIMBER PURCHASE

HASKELL

IP SHOREY 1883

LA FETRA 1883

TAGGART 1866

VD

18 JOHN BENDER TIMBER 327

JOHN BENDER 1874

JOHN W. 40

W. H. POTTS 40 80 40

150 196

ELWOOD EASLEY 1899

(POTTS) 40

W B CULLEN 1875 160

JAMES J. WEST 40

J P ENGLEHART 80

CYRUS R JOHNER 1878 80

UNIV OF CALIF 40

J.C. WEST 80

J C WEST W. L. FARLEY 40 40

J C WEST 40

W. L. FARLEY 80

20 GEO W CULL 1883 80

E.H. SINCLAIR 1879 80

29

H.T. STURGEON 1884 8

W. L. FARLEY 40

MALONE 369

CHAS G RICHTER 1884 80

HENRY GRIES 1878 80

J. F. WASHBURN 1883 160

CHAS E MILLER

THOMAS 80

DORIS 31

32 114

LES DAWSON 80

JOHN P HANES 1884 80

ALFRED E SPENCER 1874

E 133 ACRES

DAUGHERTY 1878 143 ACRES

JOHN H HOMMELL 1894

W.H. GERMAIN 1885 68

139 ACRES

GLADSTONE AVE

SA SMITH 1886

SAN JOSE ADDITION

GOODNIGHT 1887

GRAND

NRY OMAS

OR JAS BALDRIDGE AD

BALDRIDGE 1881

CHAS FISK 1884

ERKINS 1888

CHAS FISK

TOTAL ACRES

VIA TEAGUES MUD

SPRINGS

GLENDORA AVE

BONNIE COVE AVE

SUNFLOWER

VALLEY CENTER AVE

RANCHO

LA PUENTE

18

17

AZUSA VALLEY HOMESTEADER'S MAP. Drawn by the U.S. Land Office from data compiled by its records, this map is dated May 30, 1937, by its cartographer, Ernest Robertson.

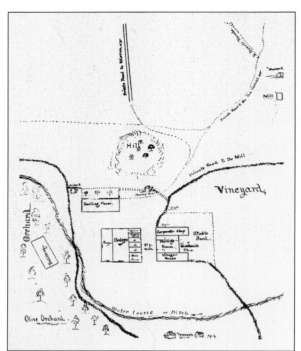

DALTON HOMESTEAD PLAN. This 1870 drawing by Henry Dalton shows the improved areas of the Azusa Rancho around Dalton Hill.

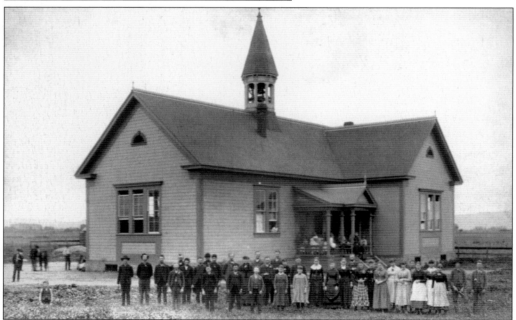

CENTER SCHOOL. Built in 1872 as the Center Grammar School, this lumber structure was the first school erected in the Azusa Valley. The 1.25-acre tract of land was donated to Azusa by Larker Barnes and located on the west end of Barnes Ranch on Broadway. Many children throughout the valley traveled miles to obtain an education at the school, which included every grade from first through high school. The building was demolished in 1928, but the bell was salvaged and is permanently displayed at the present Center Middle School.

FAIRMOUNT CEMETERY, 1876. Located in the foothills of the San Gabriel Mountains between Azusa and Glendora and atop San Felipe Hill, this cemetery is a Glendora Historical Landmark. On May 27, 1886, J. C. Preston deeded 1.8 acres of the land in the form of a trust to be used as a cemetery. A total of 225 people are buried at the cemetery, which was used until 1890, when Oakdale Cemetery was opened on Grand Avenue in Glendora.

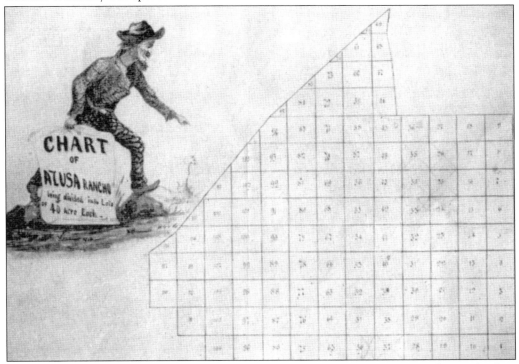

MOUND CITY. The second attempt at making a city on the Azusa Ranch occurred in 1878, when Mound City Land and Water Company bought Rancho Azusa, Rancho San Jose, and the Rancho San Jose Addition for $140,000 from Henry Dalton. The company proposed to start "Mound City" out of 40-acre farms and lots. Unfortunately, the company lacked the capital to do so, could not sell the lots and the farms, and finally had to turn the property back to Dalton.

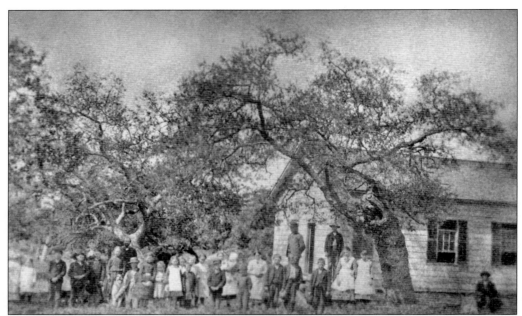

J. C. Preston School. In 1878, J. C. Preston donated land to be used for school purposes. The building was erected in 1879 and stood on the west side of Ben Lomand Avenue (Barranca Avenue) just north of the Santa Fe Railroad. Later it was moved twice, first to the northwest corner of Fifth Street and Soldano Avenue, then to the Foothill Ranch, where it was used as a tool house.

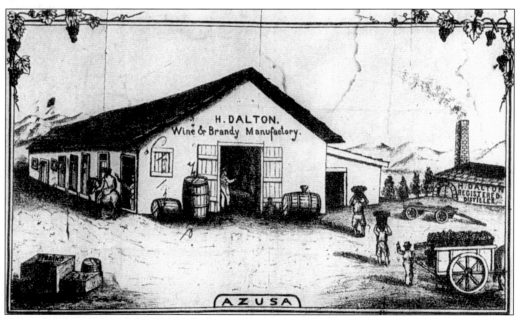

Dalton Winery. Built by Henry Dalton, who was proud of his choice in wines and brandies, the winery was the largest building on the rancho. There were over 9,000 vines at Azusa, many introduced by Henry Dalton from Europe.

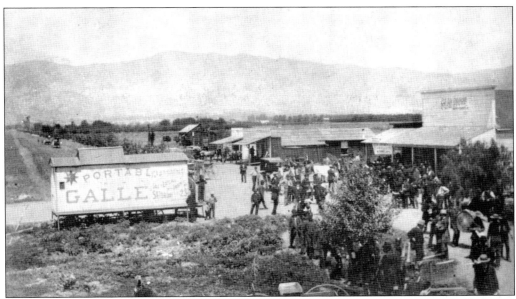

CITY OF GLADSTONE, 1886. This is the present-day corner of Citrus Avenue and Gladstone Street. A hotel was built on this same corner and trolley tracks laid from the Santa Fe tracks to the hotel. Early reports show that the reason Citrus was so narrow was because its purpose was not as a street but rather a streetcar right-of-way. Unfortunately, the land rush didn't last long enough for the new town to take, and soon all plans were abandoned. The post office was closed on September 15, 1892, and the hotel and other buildings were moved to the center of Azusa.

AZUSA LAND AND WATER COMPANY TOWN LOT ADVERTISEMENT. Notification of the public auction of the town lots appeared in the April 2, 1887, edition of the *Los Angeles Daily Herald*. In December 1886, Slauson organized the Azusa Land and Water Company, which immediately plotted the City of Azusa, laying it out in 80 blocks of 24 to 50 lots each. Interested parties stood in line the night prior to the date of the sale in order to get their first choice of lots to be offered.

THE AZUSA LAND AND WATER COMPANY

——WILL OFFER——

AT PUBLIC AUCTION

——AT——

MOTT HALL, IN LOS ANGELES,

Thursday, April 7th, at 10 o'clock a. m. of that day,

——ALL ITS——

TOWN LOTS!

Undisposed of, being nearly one-half of the lots in

THE TOWN SITE OF AZUSA.

And including the lots heretofore reserved from sale, excepting therefrom about 150 lots, which have been reserved by the stockholders of said company.

The bids will be for choice of one lot, with the privilege of taking all lots undisposed of on that street at the time of the sale, and so on until the last lots in the block mentioned are disposed of, the company reserving the right at the time to withdraw from the sale any lots or blocks that have not been offered for sale. Each person will be required to deposit $25 on each lot selected at the time that the bid is made.

☞TERMS OF SALE.—One-fourth of the amount bid on each lot to be paid within 5 days, and the balance in three equal payments, one-fourth on or before three months, one-fourth on or before six months, and one-fourth on or before twelve months after date of sale. All deferred payments to bear interest at the rate of 8 per cent. per annum. Five per cent discount will be allowed upon the full payment of the purchase price at the time of issuing the agreement.

EXCURSION TRAINS over the Los Angeles and San Gabriel Valley Railroad will run to Azusa on TUESDAY and WEDNESDAY, April 5th and 6th, leaving Los Angeles at 10 o'clock a. m. Fare for round trip, $1.25.

☞ TICKETS FOR SALE AT CALIFORNIA SOUTHERN OFFICE.

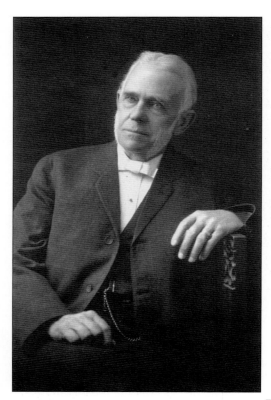

JONATHAN SAYRE SLAUSON. Born December 11, 1829, in Middletown, Orange County, New York, Jonathan Sayre Slauson was the son of David H. and Elizabeth Slauson. Jonathan married Sarah Rebecca Blum on July 22, 1858, in New York City. The couple were parents to three children: Kate (Vosburg), Louise (Macneil), and James. Jonathan died on December 28, 1905. At the request of the mayor of Los Angeles, Slauson's remains lay in state in Los Angeles City Hall, guarded by members of the Salvation Army, an organization he supported. Slauson Avenue and Slauson Playground in Los Angeles were both named in his honor.

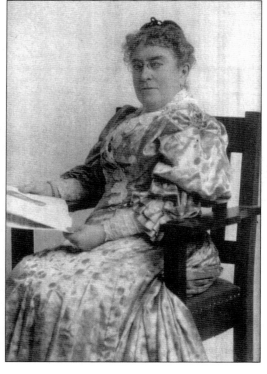

SARAH REBECCA BLUM SLAUSON. Born in New York, New York, on May 24, 1836, Sarah Rebecca Blum Slauson was of German lineage on her paternal side and Dutch-French lineage on her maternal side. She graduated from Rutgers Institute, was a very active person, and was generally regarded as benevolent, devoting time to the Salvation Army and other such organizations. Sarah Rebecca Blum Slauson died on February 20, 1920, in Los Angeles, where she is interred.

BIRD'S-EYE VIEW OF AZUSA 1887. This photograph shows the Hotel Azusa in the lower right, the Santa Fe Station in the lower left, and the old irrigation ditch, which can be spotted by the row of trees lining the banks. The business section of the town can be seen in the northern part of the 700 block of Azusa Avenue.

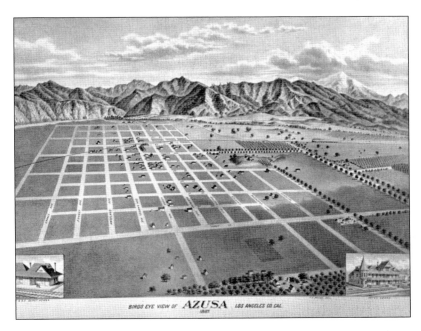

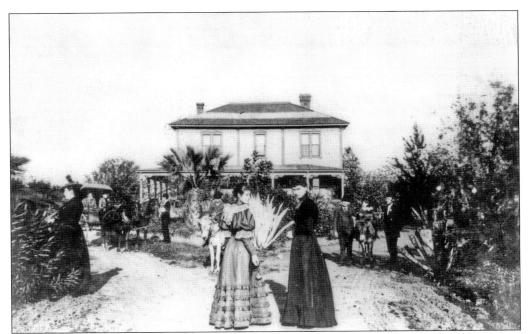

TOWN OF ALOSTA, FULLER RESIDENCE. This land was homesteaded by John Casey in 1865 and purchased by George Wright in 1873. In 1884, Harrison and Mary Ann Fuller purchased 20 acres of this land. This home would remain in the family until after 1916. "Alosta" is a derivative of the Fullers' firstborn child, Anna Losta. The Fultons purchased the home and, in 1926, opened the Fulton School for Girls, later to be known as the Mabelle Scott Rancho School for Girls. Azusa Pacific Bible College became owner in 1946.

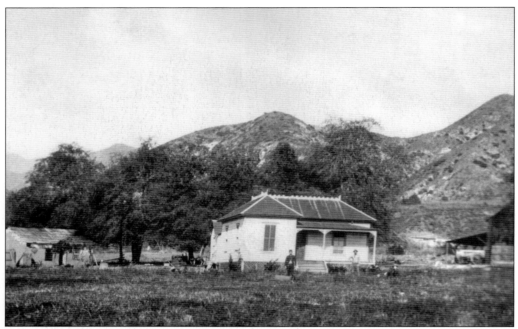

DALTON FAMILY SECOND HOME. This photograph, taken in 1887, shows the Dalton Adobe at left. Valentine Dalton, father of Roger P. Dalton, is on the right and Joe Dalton on the left. This residence stood at the center of Azusa Avenue and Thirteenth Street. It was later moved to the location of the Arthelle Ingram home.

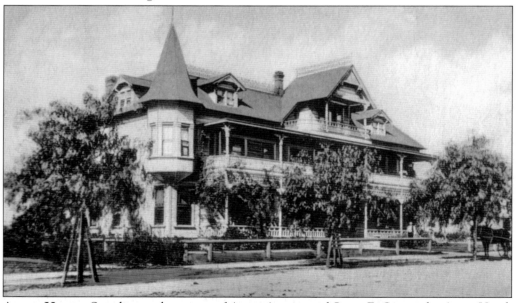

AZUSA HOTEL. Standing at the corner of Azusa Avenue and Santa Fe Street, the Azusa Hotel, built in 1887, was the first step in laying out the city of Azusa. As one of the finest hostelries in the area, the Hotel Azusa had 45 guest chambers, several sample rooms, and stabling for automobiles. It was demolished in 1927 to make way for the Azusa Improvement Company's Arcade Block Building.

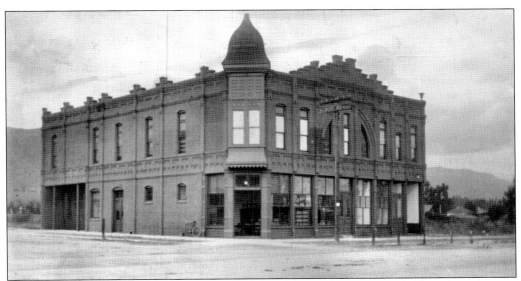

SLAUSON BUILDING AND CITY HALL. Located at the northeast corner of Alameda Avenue and Center Street (Foothill Boulevard), this was one of the three brick buildings constructed in 1887 by the Azusa Land and Water Company. The building served many purposes, such as a mercantile store, fruit house, city hall, Slauson Hall, opera house, Catholic Church, home to the Azusa Masons, the Grand Lodge, public library, volunteer fire station, and a police department. The building was demolished in 1928 to make way for the new city hall park area.

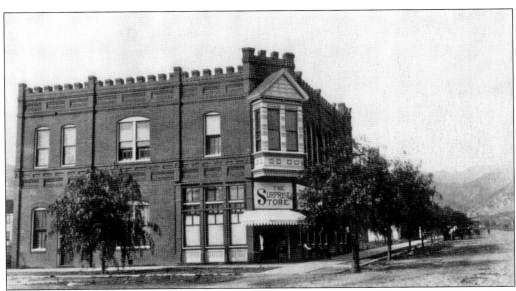

SLAUSON BLOCK. Another building constructed in the newly founded city by the Azusa Land and Water Company in 1887 originally served as the home to the Azusa Mercantile Company and the Surprise Store. It was drastically remodeled in the 1920s with stuccoed brick and a new facade. After being deemed unsafe, the building was demolished in 1985.

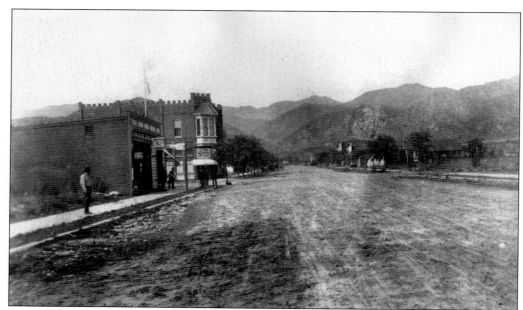

AZUSA AVENUE, 1887. Looking north toward Center Street (now Foothill Boulevard), this view shows the Slauson Block with the San Gabriel Mountains in the background. This view shows the development of the downtown and main intersection of town. Note the cement curbs and sidewalks.

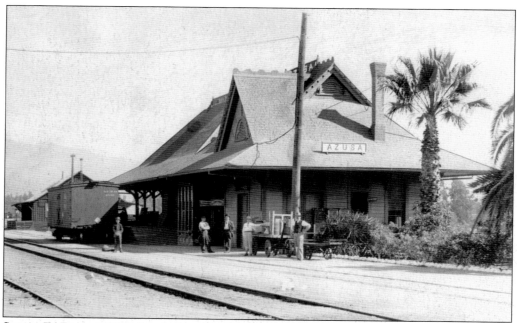

SANTA FE DEPOT, 1887. Located at Azusa Avenue and Santa Fe Street, just south of the tracks, the depot was built in 1887 for the Santa Fe Railroad. In September of that same year, the first mail delivered by rail was received, eliminating the need for the old Star Route stagecoach line. Weekend tourists would arrive at the depot and travel to the San Gabriel Canyon on horse-drawn wagons.

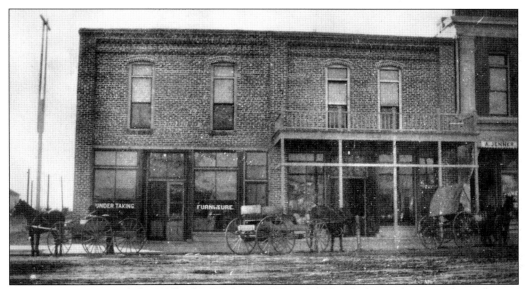

WADE BUILDING. Built by Willard J. Wade in 1887 at 619 North Azusa Avenue, this structure was once home to Clark's Funeral Parlor and F. H. Chinn's Azusa Furniture Exchange. The Wade family took up residence in the second-floor living quarters. This location was also home to the Azusa Furniture Store owned by Robert Tally. The building played a very important civic role in the early days of Azusa, serving as a meeting place for many prominent men.

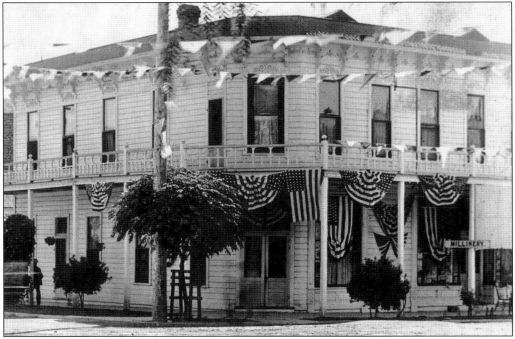

BRUNGES HOTEL. Built by John Brunges in 1884 in the town of Gladstone, this hotel was located on the corner of Citrus Avenue and Gladstone Street. It was moved to the southeast corner of Azusa Avenue and Center Street (now Foothill Boulevard) in 1900. The building was demolished in 1956.

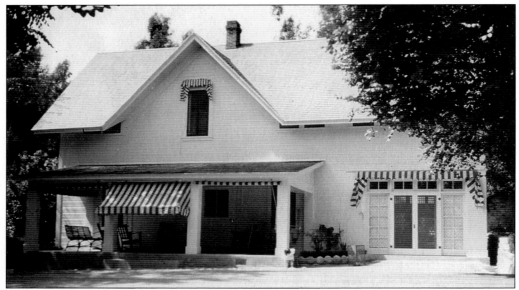

AZUSA BARN COTTAGE, 1888. Built by Hugh Livingston Macneil as a small barn, this structure was later converted into a summer cottage. After Hugh's death, his wife, Louise Slauson Macneil, lived in the small, two-story wood building until 1932, when she moved to a larger brick residence built on the site of the former tennis courts. After her death in 1949, the family rented and eventually sold the home to Carl Fredrick and Dorothy Dwight Caesar. In 1956, the residence was then sold to the Manresa Retreat Order for use by the Jesuit priests. Monrovia Nursery Company purchased the home in 1994, and it was demolished in 1995.

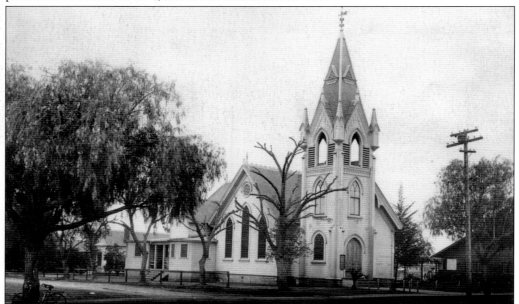

PRESBYTERIAN CHURCH. This church, built in 1888, was home to the third-oldest denomination in Azusa. The first Presbyterian church was established in Azusa on November 13, 1887, by the Rev. L. B. Crawford with 11 charter members. The Rev. J. A. Gordon was the first pastor of the church, taking charge in April 1888.

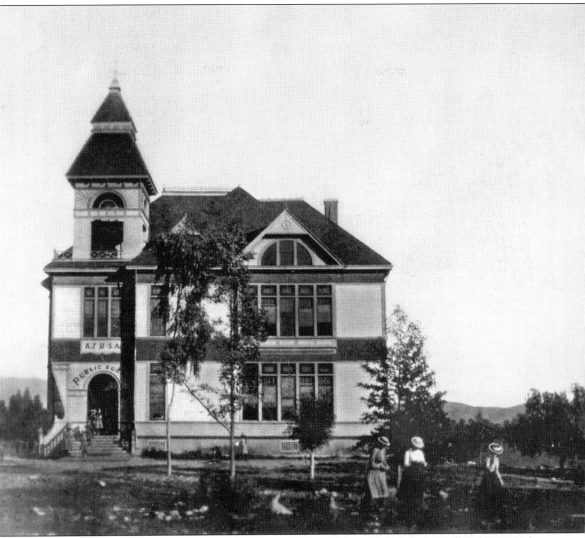

AZUSA PUBLIC SCHOOL, 1889. Located between Soldano Avenue and Pasadena, between Fourth and Fifth Streets, this Victorian-style structure was enlarged in 1907 to make room for the growing number of pupils in Azusa. It was demolished in 1920 after the construction of the newly built Riley Elementary School in 1919.

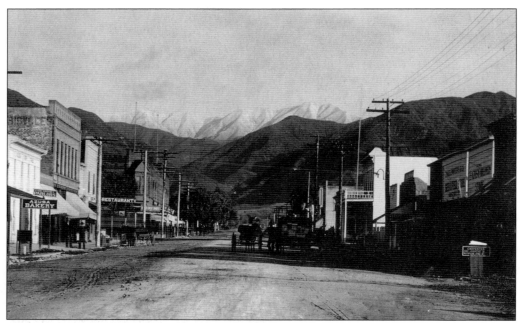

AZUSA AVENUE, 1890. This view looking north from the 600 block of Azusa Avenue toward Center Street (now Foothill Boulevard) shows the extensive development of the downtown area. Note the snowcapped San Gabriel Mountains in the background.

CITRUS UNION HIGH SCHOOL, 1891. The Citrus Union High School District was organized on July 14, 1891, and had the distinction of being the first Union High School District established in California. Originally located at the corner of Citrus Avenue and Broadway (now Gladstone Street), it was then known as Citrus High School. On December 11, 1892, high winds destroyed the original schoolhouse, so the student body relocated into this structure once located on the east side of Citrus Avenue north of Broadway.

**FIRST SOUTHERN METHODISTS'
M. E. CHURCH.** This property at the
corner of Dalton Street and Foothill
Boulevard was purchased in 1891 for the
church. While the building was still on
temporary underpinnings, it was destroyed
by the big windstorm of December 1891.
A church was then built in the 600 block
of Alameda Avenue, with stones cut from
a quarry in what is now known as the
Glendora Hills and hauled to Azusa by
wagon. This church continued to serve the
congregation until 1920, when it was sold to
the Presbyterian Home Mission Board for
Mexican Protestants. It was demolished in
1992 after suffering earthquake damage.

**AZUSA VALLEY
SAVINGS BANK,
1891.** Major
Bonebrake formed
Azusa Valley
Savings Bank and
later sold it to P. C.
Daniels. Located
at 736 North
Azusa Avenue,
this building was
constructed in
1891 and was the
first home to the
bank. Then in
1906, the First
National Bank of
Azusa merged with
the Azusa Valley
Savings Bank with
P. C. Daniels as
first president.

AERIAL PHOTOGRAPH, 1894. This shot was taken about 1894 above Sierra Madre Avenue, looking southeast toward the Old Azusa Rancho.

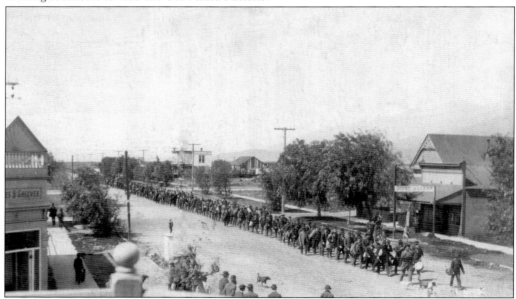

COXEY'S ARMY. The view here looks west toward Center Street (Foothill Boulevard) from the balcony of Brunges Hotel. Coxey's Army was a group of unemployed workers protesting the lack of jobs and led by the popular reformer John Coxey. The group set out from Los Angeles on March 16, 1894, with the goal of reaching Washington, D.C., with its concerns. Several towns along the way gave them food and sped them onward. When Coxey's Army traveled through Azusa, the townspeople came out to watch them, but only a very few are reported to have joined them. Coxey's Army arrived in Washington in May 1894.

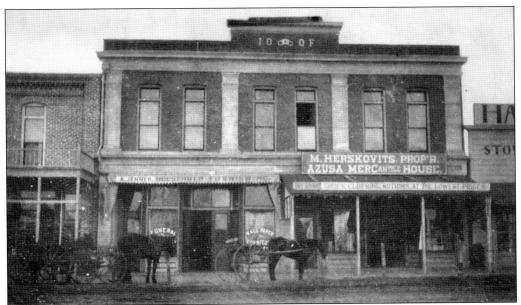

BARKER BUILDING. Located on the west side of Azusa Avenue, between Sixth Street and Foothill Boulevard, this building was erected in 1894 by William T. Barker. Throughout the years, the structure housed a general store, lodge room, the International Order of Odd Fellows, and the Azusa Masonic Lodge. During the decade after it was built, the Barker Building was the scene of some of the largest fraternal gatherings in California. Azusa Masonic Lodge moved from this building to their temple on San Gabriel Avenue in January 1908.

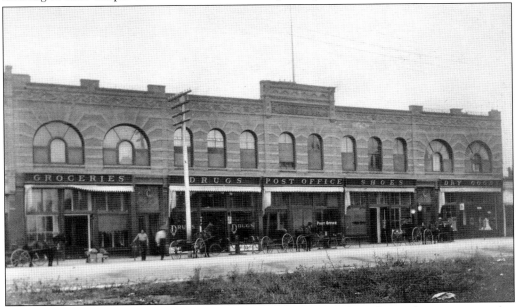

A. P. GRIFFITH BLOCK, 1894. Built by Alfred P. Griffith, a local rancher and citrus grower, this building was located on the west side of the 700 block of Azusa Avenue. It housed numerous businesses and offices throughout its existence. Due to significant earthquake damage, it was demolished in the 1980s.

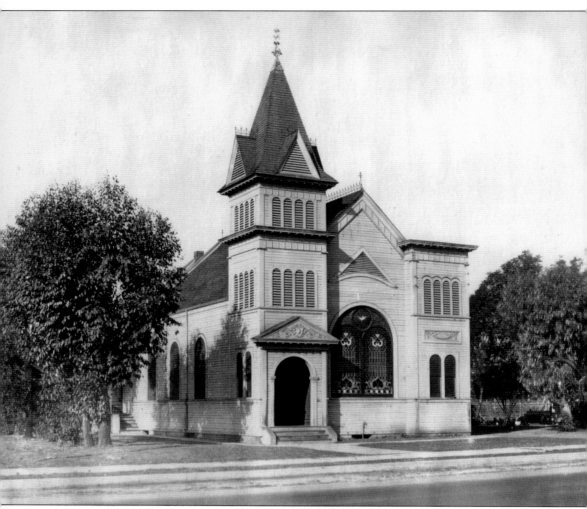

AZUSA BAPTIST CHURCH. The oldest existing church building in Azusa was once home to the oldest existing denomination in Azusa. Located on the northwest corner of Azusa Avenue and Fourth Street, the Azusa Baptist Church was organized on June 21, 1873, with seven members. This building was dedicated on February 16, 1896.

Two

THE BEGINNING OF THE 20TH CENTURY

At the end of the 19th century, Azusa was already established as a full-fledged city with a population of 1,200. Although Azusa had a strong "no saloon" policy, it did boast having its own electric lighting and water plant, city hall, library, paved streets with sidewalks, bank, weekly newspaper, packinghouses, lumberyard, ice and cold storage plant, machine shop, curio factory, and many mercantile houses. The year 1898 marked the beginning of the Azusa City School District (which boasted having one of the finest high schools in the region); the establishment of a strong connection to fraternal organizations including the Masons and the International Order of Odd Fellows; and the founding of the Azusa Chamber of Commerce, whose purpose was to advance the interest of the city to nonresidents.

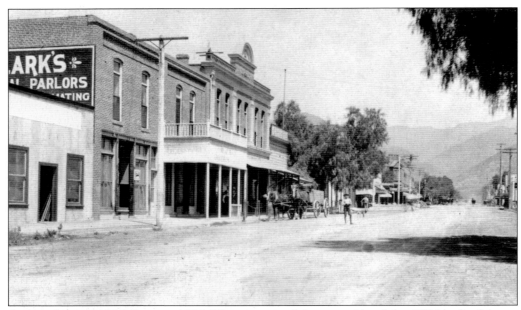

AZUSA AVENUE 600 BLOCK, 1895. This view is of the west side of the 600 block of Azusa Avenue and shows the Willard J. Wade and William T. Barker Buildings. Clark Funeral Home is seen on the ground floor of the Wade Building.

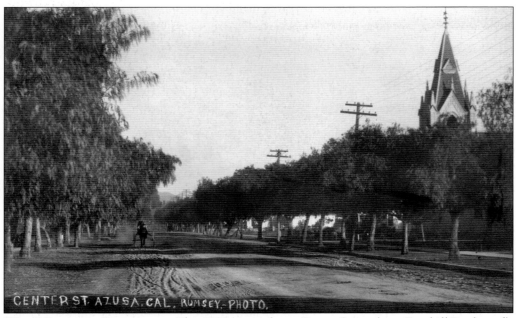

"OLD" FOOTHILL BOULEVARD. This 1895 image shows Center Street (now Foothill Boulevard), which was once lined with California pepper trees and made of dirt. The original Presbyterian church can be seen at right.

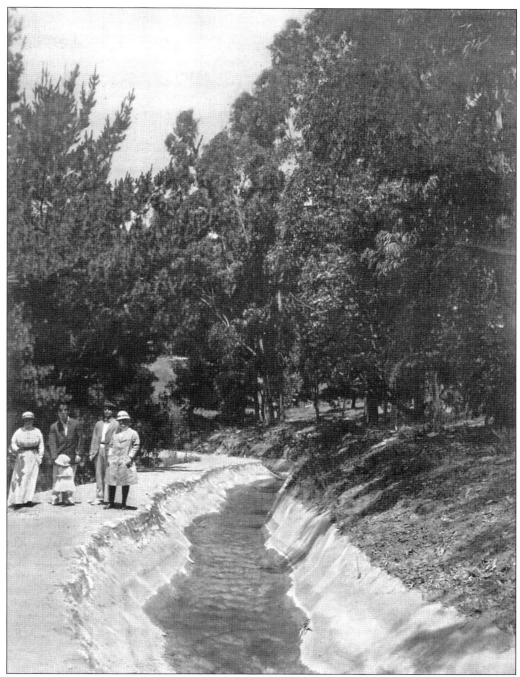

THE COVINA CANAL. The Macneil family is seen walking along the Covina Canal. This ditch, which dates back to 1843 when it was originally constructed by Don Luis Arenas (and later enlarged and improved by Henry Dalton), is thought to be the earliest permanent water system utilizing the San Gabriel River waters. The canal ran through the Azusa Rancho.

FIRST CHRISTIAN CHURCH. Located on the east side of the 500 block of Azusa Avenue, the structure was built in 1890 for the First Christian Church of Azusa, which was organized in 1888. Over the years, the facade has been altered and the denomination has changed.

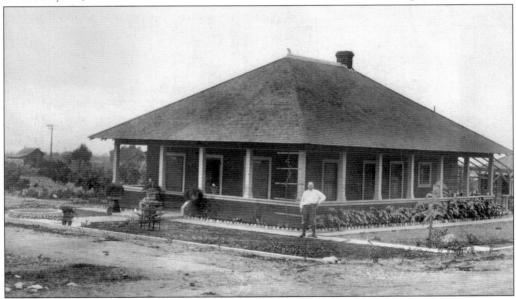

JOSEPH RUSSELL DALTON RESIDENCE. Born in Azusa in 1869, Joseph Russell Dalton was the youngest son of Henry Dalton and Maria Zamarano. Dalton is pictured standing in front of the home that was built for him and his wife, Trinidad Macias. The building was once located at the southwest corner of San Gabriel and Sierra Madre Avenues.

PALM DRIVE, 1898. One of Southern California's most dramatic plantings of *Washingtonia filifera* lined Palm Drive. The history of the 226 desert fan palms and the double 1,300-foot driveway with the pear trees in between can be traced back to Slauson's feuding daughters, Kate and Louise. Both received portions of the property as wedding gifts. The second, private Vosburg driveway was constructed to ensure that the sisters could avoid crossing each other. Although Palm Drive was on private property, it served as a symbol for the city of Azusa, gracing the covers of brochures and postcards. Palm Drive even served as a whistle stop for Pres. William H. Taft, who was greeted on October 12, 1909, by over 1,000 schoolchildren from Azusa, Covina, and Glendora.

MEYERS BAKERY, 1898. Located at 631 North Azusa Avenue, this structure originally opened as Meyers Azusa Bakery. It later served as the home and business for the George J. Abdelnour family, who ran a dry goods and Levi store.

R. M. Sippel Building. Located on the south side of Center Street (now Foothill Boulevard), this building housed a garage and stables below and a residence above. Sippel was a dealer in new and used buggies and carriages, a trade that was very successful before the introduction of the automobile.

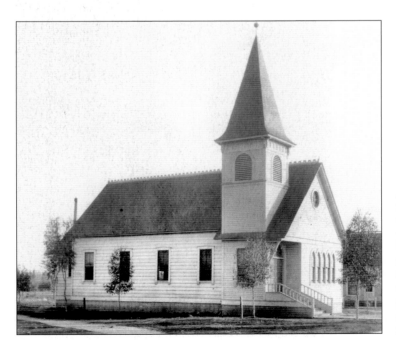

New M. E. Church. Located on Alameda Avenue, this was the first home to the M. E. church of Azusa. This structure soon became obsolete, and the growing congregation replaced it with a larger facility around 1919.

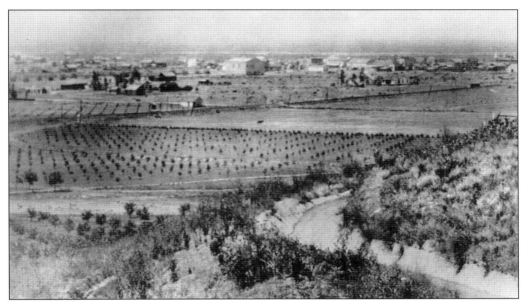

AERIAL PHOTOGRAPH, 1898. This shot was taken during the year of the city's incorporation, looking southwest toward town from the Covina Canal irrigation ditch.

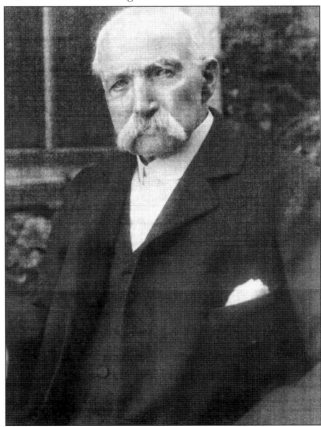

HENRY. A. WILLIAMS, FIRST MAYOR OF AZUSA, 1898. After moving to Azusa in 1888, Williams was elected to be the first president of the board of trustees of the new city of Azusa, a position that evolved into mayor. He also served as president of the Azusa City School Board and owned and operated H. A. Williams Grocers. Williams lived to be 99 years old.

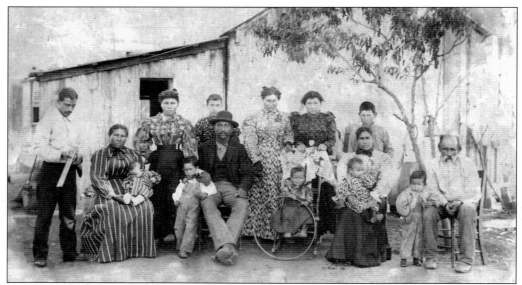

PORTRAIT OF FAMILIES, 1899. This photograph includes members of the Alvitre, Ruelas, Lopez, and Trujillo families, early founding families of Azusa dating back to the rancho days. The photograph was taken to commemorate the incorporation of the township of Azusa in December 1898. From left to right are Elias Montoya Trujillo, Eugenia Alvitre Lopez, Rose Lopez Noriega (on Eugenia's lap), Isabella Lopez, Justo "Jess" Lopez, unidentified, Carlos A. Ruelas, Viviana Lopez Ruelas, unidentified (child holding hoop), Mariana Lopez, Martin Lopez (on Lucy Ruelas Lopez's lap), Lucy Ruelas Lopez, Vincente Alvitre Lopez (behind Lucy), John Lopez, and Onofre Lopez.

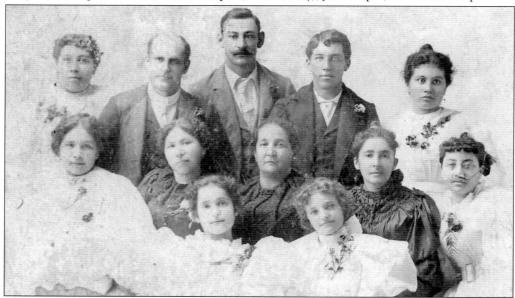

AZUSA CATHOLIC CHOIR, 1899. This modest group of early prominent citizens performed at the services held in the Slauson Hall prior to the erection of the Catholic church. Pictured here from left to right are (first row) Alice Wolfskill and Isabella Wolfskill; (second row) Angelita Grijalva, Carmen Meyers, Guadalupe Z. Dalton, Christina J. Dalton, and Carlota Salazar; (third row) Dionicia Grijalva, Henry F. Dalton, Martin Lee Duarte, Thomas Grijalva, and Carmen Grijalva.

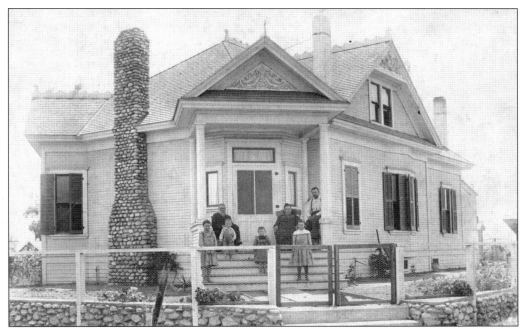

CHAS REAM HOUSE, 1899. Built in 1887 for the Dodsworth family and later inhabited by Chas Ream and his family, this home was located on the southwest corner of Dalton Avenue and Tenth Street. Pictured from left to right are (first row) Martha, Merlyn, Edith and Eva Ream; (back row) Zachariah Ream (father of Chas O. Ream), Nancy Alameda "Ollie" Ream, and Chas O. Ream. The family came to Azusa in 1889.

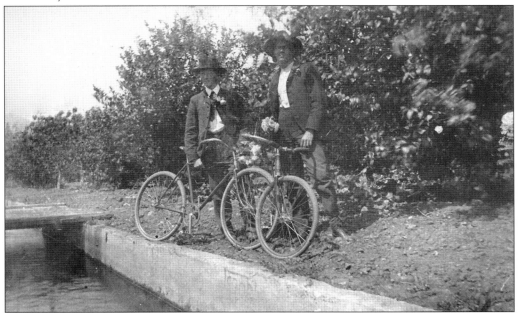

AZUSA DITCH, 1900. Taken at the Azusa Foot-Hill Citrus Ranch, this image shows two bicyclists posing in front of the old Azusa Ditch, which once flowed through the Rancho Azusa property.

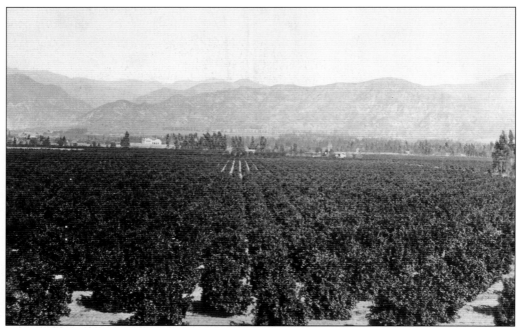

AERIAL VIEW OF AZUSA, 1902. This land is now occupied by Azusa High School. At the time this photograph was taken, Citrus Union High School had been recently completed.

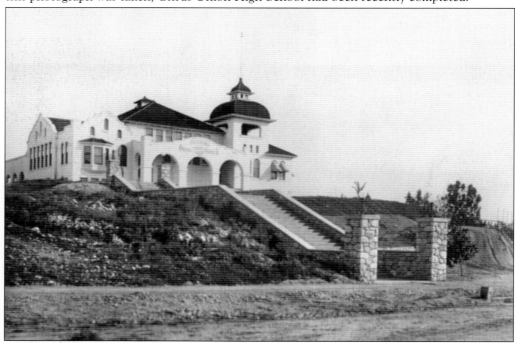

CITRUS UNION HIGH SCHOOL, 1902. The new Spanish-style building was located on Dalton Hill on the east side of High School Street (now Cerritos) and Sixth Street. Citrus Union was demolished in 1959. Citrus College was established here in March 1915 as the 11th junior college in California.

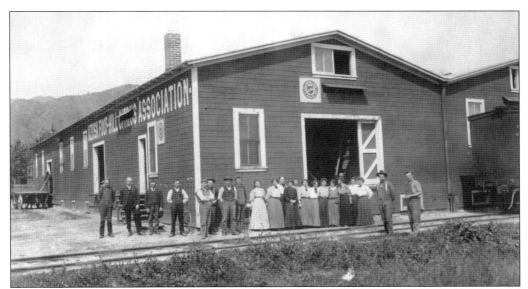

AZUSA FOOT-HILL COMPANY PACKINGHOUSE, 1902. Located north of the Santa Fe Railroad tracks between Soldano and Pasadena Avenues, these were considered to be state-of-the-art and the highest standard in fruit packing. The four large, rectangular-shaped packinghouses, with loading docks extending the width of the building, measured a total of 200 by 240 feet in size, had horizontal wood siding, low-inclined gable roof lines, and multiple large sliding doors so that shipments could be easily loaded into train cars off either the Santa Fe Railroad or the Pacific Electric Railway.

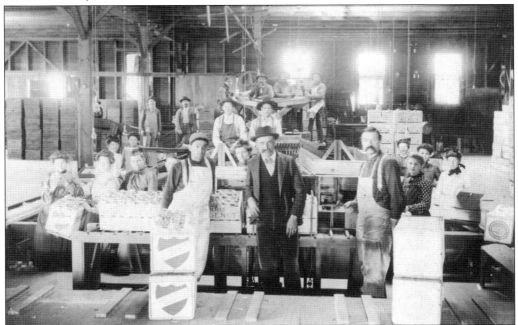

INTERIOR OF AZUSA FOOT-HILL CITRUS COMPANY PACKINGHOUSE. The Azusa Foot-Hill's Red Shield crate label was the standard of excellence for citrus fruits. William A. Sproul is seen in center foreground, and A. J. Clark is on his right.

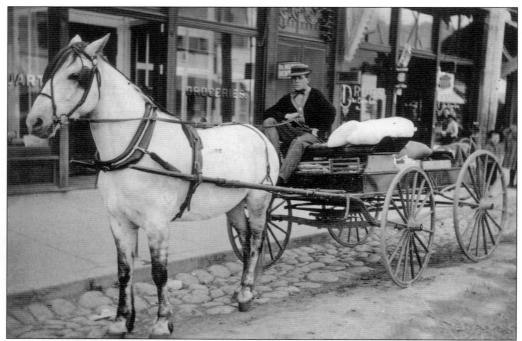

KORT MEIER DELIVERING GROCERIES BY CARRIAGE. This photograph was taken in front of the Smith and Stuart Grocery Store, once located at the 700 block of Azusa Avenue in the Griffith Building. Meier, who at a young age delivered groceries, eventually owned and operated his Chevrolet dealership and garage located on Foothill Boulevard in the 1930s.

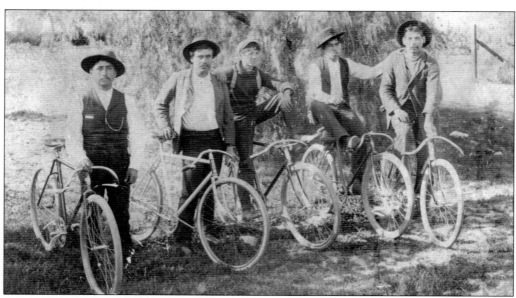

AZUSA BICYCLE TEAM, 1902. Formed at a time when bicycling was a popular pastime, this Azusa bicycle team was known for its unique riding styles and techniques. Pictured from left to right are Albert Perez, Martin Bracafonte, Joe Aguayo, Manual Ruelas, and P. Aguayo.

44

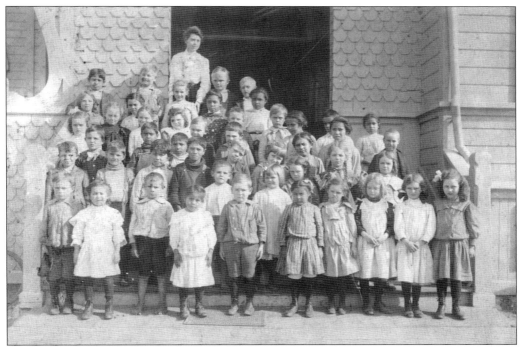

AZUSA PUBLIC SCHOOL KINDERGARTEN CLASS, 1903. The children pictured here were members of one of the first kindergarten classes in Azusa. This photograph demonstrates the economic and ethnic diversity of the Azusa schoolchildren, who all attended the same school and were instructed by the same teachers. The Azusa School District was considered to have the best academic programs in the valley and, formed in 1898, is one of the oldest school districts in the area.

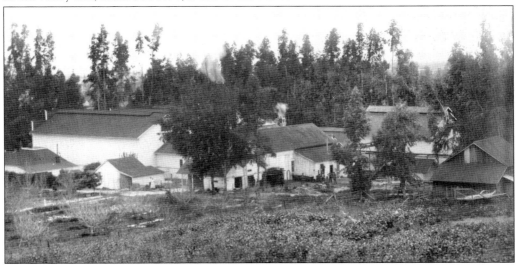

AZUSA ICE AND COLD STORAGE COMPANY. This factory was one of the most essential businesses in the early days of Azusa. Once located at the east end of Ninth Street near Pasadena Avenue, this plant had the capacity to produce 50 tons of ice daily and supplied all the ice used by the Santa Fe Railroad on its lines between Los Angeles and Barstow and Los Angeles and San Diego. It was destroyed by a fire in 1922.

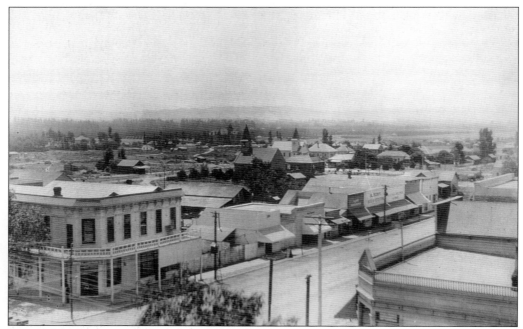

EARLY GROWTH, 1903. Cornelius Smith took this photograph from a ladder atop the C. A. Griffith Building, looking southeast with the intersection of Azusa Avenue and Center Street (Foothill Boulevard) in the foreground.

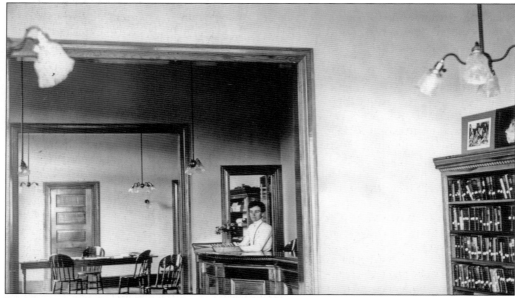

LIBRARIAN ANNIE TAYLOR. This photograph, taken in 1904, shows Azusa's first librarian, Annie Taylor. The Azusa Free Library had just moved from the Clapp Building, located on Azusa Avenue, to the old Azusa City Hall, on the northeast corner of Alameda Avenue and Center Street (Foothill Boulevard).

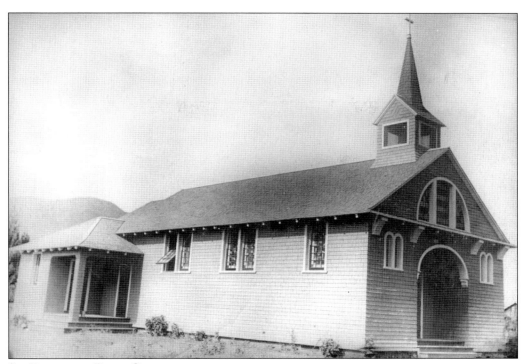

St. France of Rome Catholic Church, 1905. The Catholic church was organized in Azusa on July 20, 1895. Located at the northwest corner of Pasadena Avenue and Center Street (Foothill Boulevard), it was built by contractor Edwin Mace at a cost of $1,984, an amount donated by parishioner John T. Lindley. First Mass was held in the new church in December 1905 with Rev. J. J. Sheehy of Monrovia presiding. Rev. Michael Geary was the first resident pastor of this congregation, from 1907 to 1923. The church was demolished in 1960.

Constable Bill Hamblin. Born in Bloomfield, Indiana, W. I. Hamblin of Azusa Township served as a peace officer beginning at the age of 12 years. He came to California in 1893 and joined the sheriff's office of Los Angeles County in 1895. In 1906, he was reelected as constable. Hamblin was one of the few remaining "Sons of the Old West," having toured with "Buffalo Bill" Cody and worked at Cody's famous "Scout Rest" Ranch in North Platte, Nebraska.

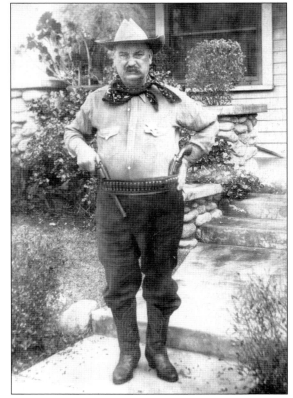

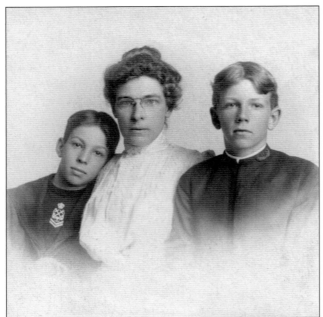

KATE SLAUSON VOSBURG. Born on May 24, 1861, in New York City, Kate married John Selah Vosburg in 1885 and had three children: Roydon, Keith (right), and Murray (left). Vosburg moved to Azusa from Los Angeles in 1918. Vosburg, known affectionately as "Aunt Kate," was noted for her philanthropy, helping to establish many of the civic organizations in the city such as the Azusa Women's Clubhouse, Azusa Health Clinic, and Slauson Memorial Park. Vosburg died at her home on February 16, 1931, where her private funeral services were held. Her ashes were placed in a copper urn and buried in the upper portion of her property.

VOSBURG HOUSE, 1907. A March 1907 *Pasadena Star and Azusa Pomotropic* newspaper article announced the upcoming construction of the home at a cost of $10,000. The house, built on the Rancho del Alisal, was designed by 14-year-old Murray Vosburg and constructed by Fredrick A. Frye. It reflects the character of the California-style architecture popular during the era. Originally used as the Vosburgs' summer getaway, it became the family's permanent residence in 1918. After his mother's death, Murray and his family occupied the house. They then leased it to various tenants until its sale in 1952 to the Monrovia Nursery Company, when it became the residence for the Rosedale family and later home to Martin W. Usrey, a key nursery developer, and his family. In 1955, the building became the company's headquarters.

LOUISE SLAUSON MACNEIL.
Born in 1864 in New York
City, Louise married Hugh
Livingston Macneil in 1884 and
had two children, Sayre and
Marion (Smith). She made her
home in Azusa in 1892 at the
Rancho Los Cacomites in the
northeastern part of the city.
Louise passed away on February
22, 1949, at the Huntington
Hotel in Pasadena. Services
were held at her former home
in Azusa.

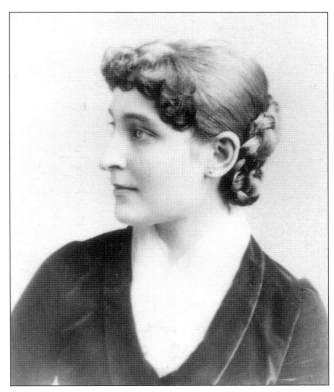

JAMES SLAUSON. Born on October 2,
1865, in Austin, Nevada, Slauson came
to California with his parents. At the age
of 15, he became a messenger for the Los
Angeles County Bank. He remained with
the bank for five years and then became
secretary of the Azusa Land and Water
Company and later chairman of the board
of directors of the Azusa Foot-Hill Citrus
Company, president of the Azusa Water
Company, and director of both the First
National Bank of Azusa and the Azusa
Valley Savings Bank. Slauson died at his
home in Santa Monica, California, on
June 8, 1922.

LONGFELLOW ELEMENTARY SCHOOL, 1907. Built in 1907 to help accommodate Azusa's growing population, the school was named in honor of poet Henry Wadsworth Longfellow. Located on Angeleno Avenue between Tenth and Eleventh Streets, the structure had few additions over the years. In the late 1950s, the structure was demolished to make way for a new, more modern and larger replacement.

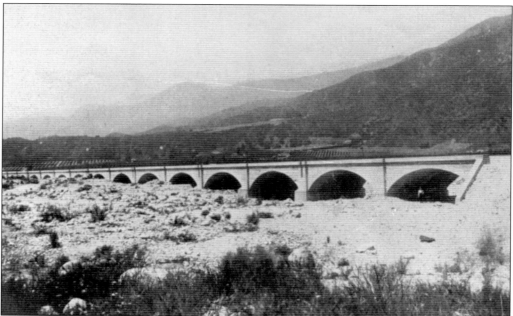

PACIFIC ELECTRIC RAILROAD BRIDGE, 1907. Known as the largest cement bridge in the world when it was completed, this structure spanned 1,016 feet, was 24.5 feet wide, and consisted of 18 reinforced-concrete arches raised above the riverbed by 17 piers at 57-foot intervals. Construction of the bridge, created to carry the Red Cars across the San Gabriel River, began in 1905 under the direction of railroad tycoon Henry Huntington. The bridge was used through 1951, when the electric rail transportation system was discontinued in Azusa.

AZUSA MASONIC LODGE NO. 305 F&AM, 1908. The search for a permanent home for this lodge began in 1906. On March 29, 1907, John W. Calvert donated a parcel of land located at 510 North San Gabriel Avenue, and that evening the structural design was submitted by Edwin Mace. The cornerstone was laid on August 10, 1907, and the first meeting was held in the new temple on January 10, 1908. A formal dedication was conducted on February 28, 1908. This two-story, mission-style building with its parapet roof has been the home of various Masonic gatherings since its construction.

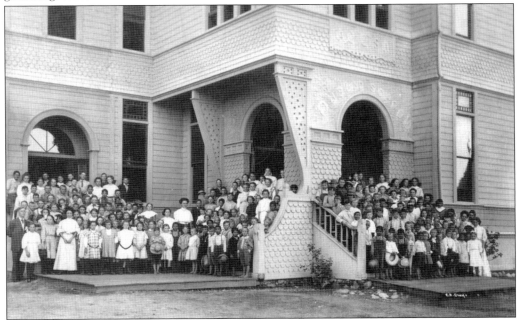

AZUSA PUBLIC SCHOOL, ALL-CLASS PHOTOGRAPH, 1908. This photograph was taken just after completion of the new wing addition to the Victorian structure. The entire student body, staff, and faculty are present.

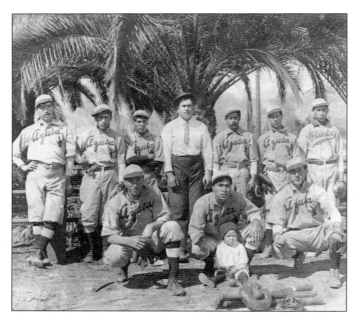

AZUSA CITY BASEBALL TEAM, 1909. Taken on the west side of the Azusa Santa Fe Train Station, this photograph features team manager Mike and team mascot Arthur Cruz Trujillo as the only two without a uniform on. Pictured from left to right are (first row) Arthur Cruz Trujillo; (second row) Frank "Chico" Cruz, Marcos Cruz, and Roger Dalton; (third row) unidentified, team manger Mike, Richard "Richie" Ochoa, Raymond Macias Alva, and Frank "Chico" Mongels. This team was very well known throughout the San Gabriel Valley.

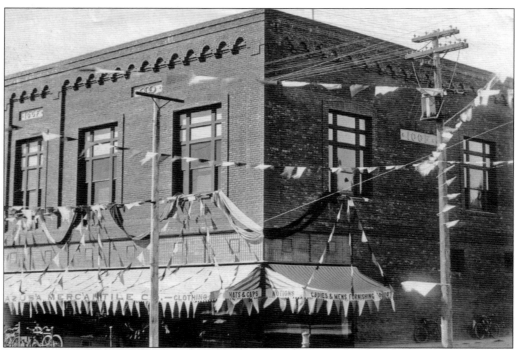

ODD FELLOWS BUILDING, FEBRUARY 1909. Located on the southwest corner of Azusa Avenue and Center Street (Foothill Boulevard), this structure was the final home to the Azusa Chapter of the International Order of Odd Fellows Lodge, which moved from 623½ North Azusa Avenue. With its meeting rooms and hall on the second floor, the ground floor was used as retail. Arnold's Market occupied this site for a number of years. The building was demolished in the early 1970s.

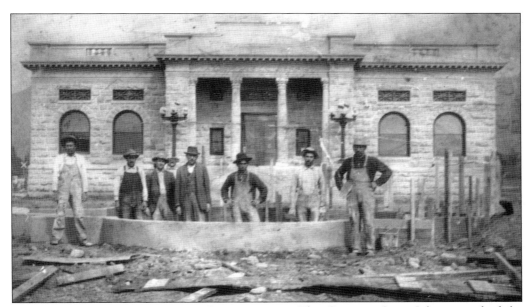

CONSTRUCTION OF AZUSA PUBLIC LIBRARY, 1909. This Carnegie Grant Library was built by the B. R. Davidson Contracting Company and designed by architect Norman E. Marsh. This September 1909 photograph was taken after the completion of the fish pond, located in the front center of the new library. Pictured from left to right are Jesus Toscano, J. H. Culler, John Taylor, Jake Wilsford, Manuel M. Ruelas (foreman), and Frank Moraga.

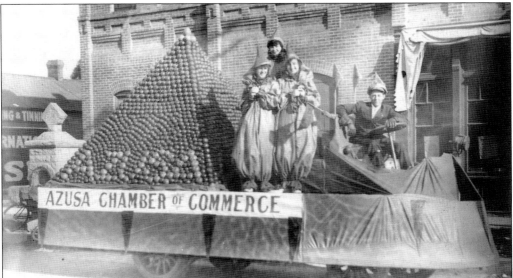

1910 LOS ANGELES ORANGE DAY PARADE. This March 15, 1915, image was taken at the corner of Azusa Avenue and Center Street (Foothill Boulevard) of the Azusa Chamber of Commence float. Yama Yama Girls were Ruby Miller, Ethel Downing, Juanita Dunlap, and Eva Conklin. The driver at right is Donell M. Spencer. The float consisted of an orange pyramid made of 1,800 oranges that weighed 1.5 tons and had the Azusa name made in 2-foot letters. It was followed by 25 students from the Citrus Union High School who distributed fruit. By the end of the parade, the pyramid had been reduced to only 2 visible feet.

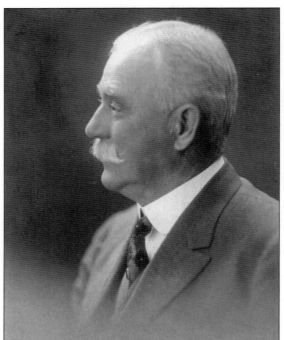

JOHN T. LINDLEY. Formerly the postmaster of Ontario, California, Lindley came to Azusa in 1902 and began his association with the Slauson family when the Azusa Foot-Hill Citrus Company was formed. Lindley served as president of the company and director of the ACG Fruit Exchange as well as an active director of the First National Bank of Azusa. He was an active member of the St. Frances of Rome Catholic Church, having donated a large portion toward its construction. Lindley died in Azusa on July 30, 1920, at the age of 63.

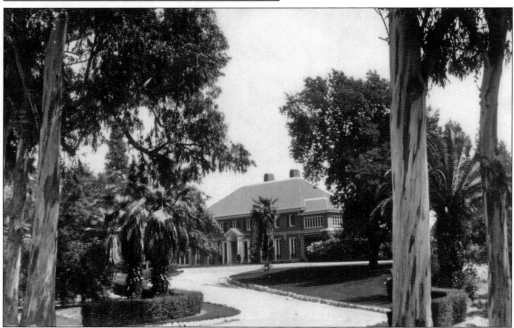

LINDLEY RESIDENCE, 1912. Construction for this building on Center Street (Foothill Boulevard) began in April 1911. Noted Architect Robert David Farquhar designed the two-and-a-half-story, wooden-framed, Colonial Revival home located on property that was once part of the original ranch. The Lindley family lived in the home until its sale in 1937 to Past National Commander Mark McKee. In 1943, Mabelle Scott Anderson purchased the home. She was the founder of the Mabelle Scott Rancho School for Girls in Azusa.

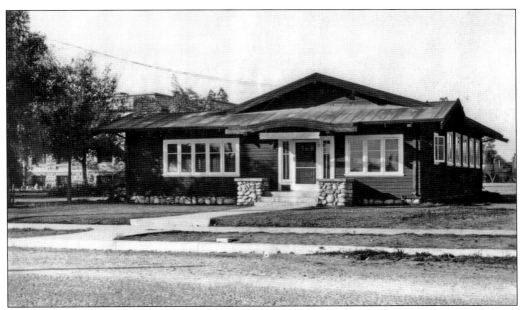

ORIGINAL AZUSA WOMEN'S CLUB CLUBHOUSE, 1912. Once located on Dalton Avenue, this Craftsman bungalow was built at a cost of $6,176 and was the first permanent home to the Azusa Women's Club, which was founded on January 15, 1901, by Sara L. Dole (then principal of Citrus High School) with the assistance of 17 other charter members. The building later became home to the City of Azusa Department of Public Works.

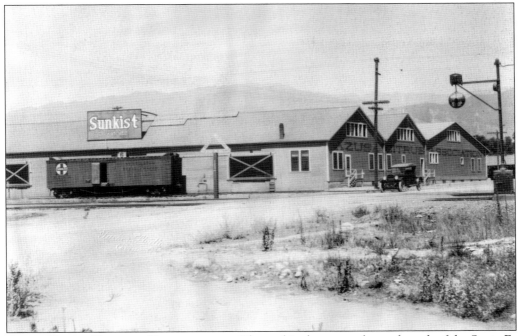

AZUSA CITRUS COMPANY PACKINGHOUSE. The packinghouse was located north of the Santa Fe Railroad tracks and Alameda Avenue. Operations ceased in the 1950s shortly after the structure was demolished.

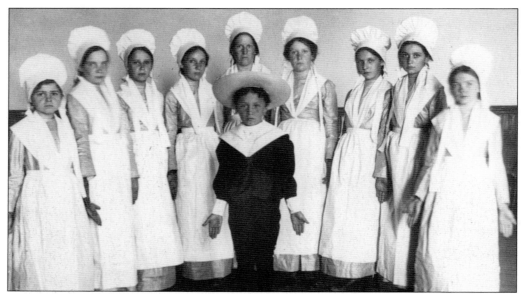

BUDDY DE SYLVA, 1913. Seen in center of this photograph in a school stage production of *The Shaking Quakers* is George Gard "Buddy" De Sylva, a Broadway lyricist, producer, and musician of the 1920s. Supporting cast members from left to right are Lyda Hendrick, Ruth Lee, Lucile Moody, Fay Judd, Grace Ellington, Leona Ellington, Bessie Robinson, Tressie Eason, and Edna Pierce. De Sylva was born in 1895 in New York and educated in the Azusa school system, graduating from Citrus Union High School in 1913. He wrote over 500 songs, including for Al Jolson and Shirley Temple and in collaboration with George Gershwin and Nacio Herb Brown. Upon his death on July 11, 1950, De Sylva owned 8,000 shares of Capitol Records.

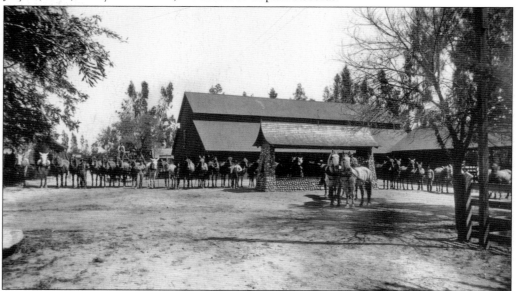

AZUSA FOOT-HILL CITRUS COMPANY RANCH BARN AND STABLES, 1914. These ranch structures were built by local contractor Fredrick A. Frye for the labors of the Azusa Foothill Citrus Company Ranch. This site included the home for the ranch manager and laborers, the barn and horse stables, and even a lodge room for meals and a pool area.

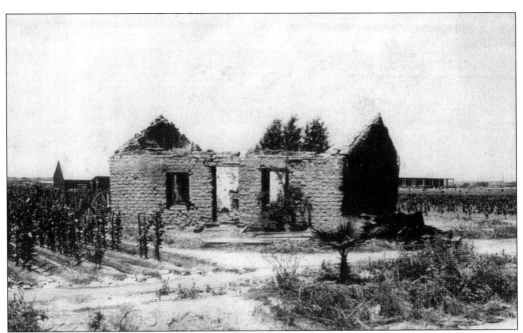

DALTON ADOBE IN RUINS, 1914. Neglected and badly in disrepair, the ruins of the old adobe were no longer of any use to the Dalton family and were demolished in 1914.

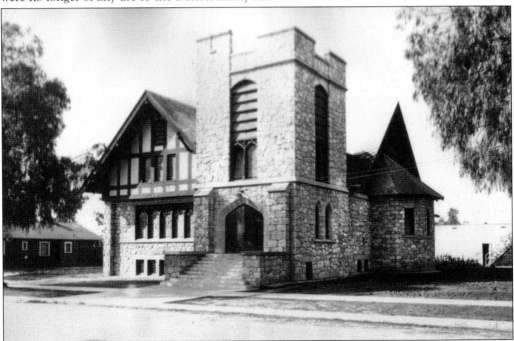

NEW PRESBYTERIAN CHURCH, 1914. Built in order to replace the former structure that burned down in 1913, this church was located on Soldano Avenue on the site of the original church. This structure was used until 1950, when the congregation outgrew it and a new building was erected to the north.

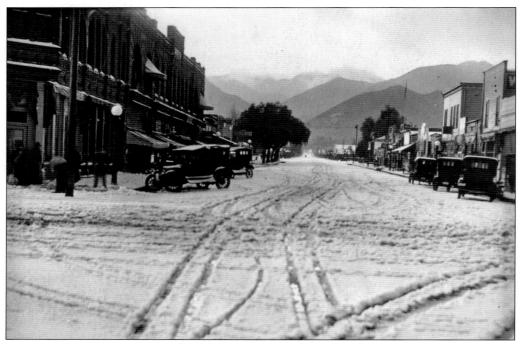

SNOWSTORM, 1913. This photograph, taken from Center Street (now Foothill Boulevard) looking north at Azusa Avenue, shows the result of a heavy snow-like hail that fell unexpectedly.

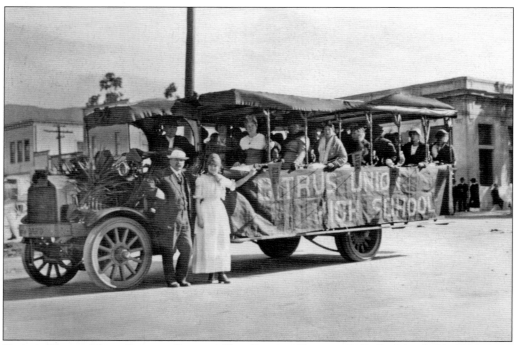

CITRUS UNION HIGH SCHOOL ORANGE DAY PARADE FLOAT, 1915. On March 20, 1915, these female students were photographed on their way to the Orange Day parade in Los Angeles.

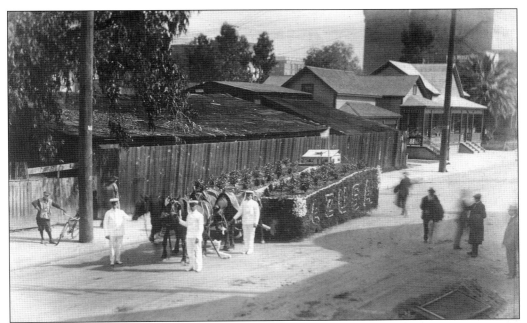

FIESTA DE LAS FLORES LOS ANGELES PARADE, MAY 3, 1915. The float, constructed by O. A. Gierlich, consisted of a hillside bungalow home surrounded by orange groves loaded with tiny fruit and marked by a long driveway bordered with golden arborvitae and dwarf begonias. It won ninth place in a field of 19 and a $75 prize. The parade signaled the opening day of the Shooting Up the Town Rodeo and proceeded down Broadway through downtown Los Angeles.

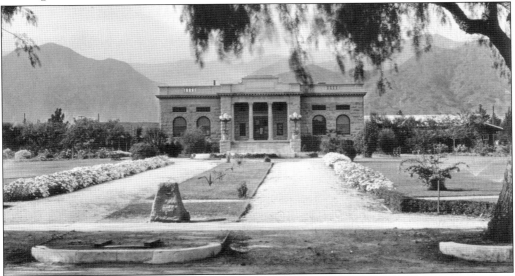

LIBRARY PARK AND CARNEGIE GRANT LIBRARY. Located on Center Street (now Foothill Boulevard), the library was dedicated on January 18, 1910. It was built with a $10,000 grant from the Andrew Carnegie Foundation, with the City of Azusa donating the land and $2,000. The Azusa Women's Club and WCTU furnished the juvenile room. It was demolished in 1975. This photograph was taken on July 16, 1915. The structure was demolished in 1975.

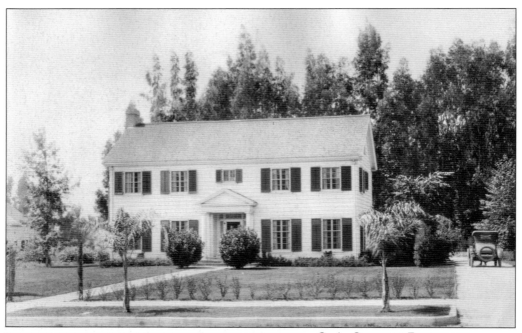

C. A. GRIFFITH RESIDENCE.
Located at 613 North Cerritos
Avenue, this home was built in 1918
for Charles A. Griffith, who served
as general manager of the Azusa
Foot-Hill Citrus Company. Newman
Center Campus Ministry acquired
it in 1961, and it became a private
residence again in 1995.

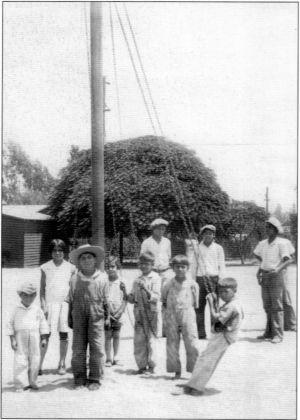

**PLAYGROUND FOR MEXICAN
CHILDREN, JULY 1919.** Built
through the efforts of Kate
Slauson Vosburg, who was known
as the "patrona of the Mexican
community," this playground was
located north of the Azusa Free
Clinic. The park was equipped
with benches, swings, sandboxes,
drinking fountains, and restrooms.

AZUSA CLINIC AND SETTLEMENT, SEPTEMBER 1919. Located at 160 North Azusa Avenue and founded by Kate Slauson Vosburg, this one-story, California-style bungalow included an emergency hospital and was equipped with all the accommodations and modern technologies of the time. The expense and upkeep of the facility was financed through Vosburg. The first staffers were Mrs. McFarland and Mrs. F. L. Dingman, the city's health official. After the infamous flu epidemic of 1918, greater public health care became a national concern.

OLIVER T. JUSTICE. Known as "Old Hickory," Oliver T. Justice served as the first postmaster for the Azusa township in the 1870s. He also served as president of the Azusa School Board at one time. After saloons were voted out of Azusa, he lived a hermit's life in the San Gabriel Canyon. This spring 1919 photograph taken by Earl Philleo shows Justice at the Iron Forks of the East Fork of the San Gabriel River in spring 1919. He died in June 1929.

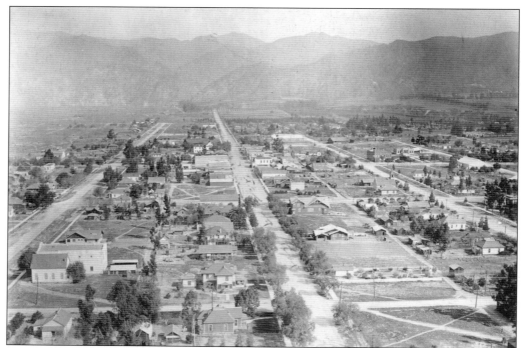

AERIAL VIEW TAKEN BY A BALLOONIST. This 1919 photograph looks north above Azusa Avenue and shows the vast growth and development of Azusa.

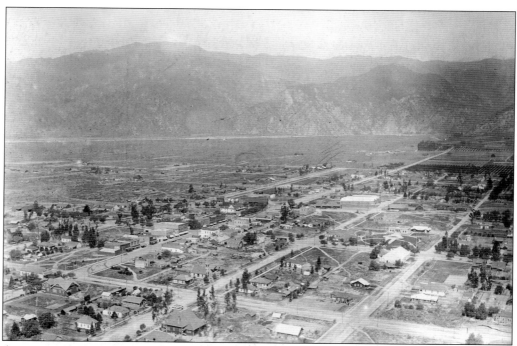

ANOTHER AERIAL VIEW. The same balloonist who shot the previous image also took this photograph in 1919, looking northeast above Dalton Avenue.

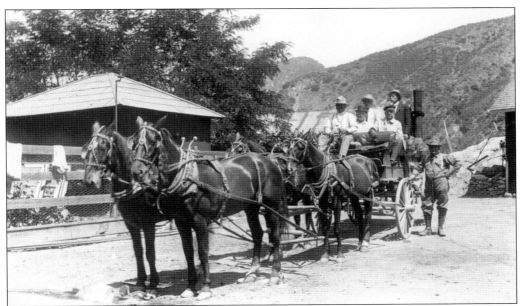

RALPH M. FOLLOWS STAGECOACH. Born in England, Follows immigrated to the United States due to his ill health. A charter member of the Azusa Chamber of Commerce, Follows was founder of Follows Camp, a well-known health resort located in the East Fork of the San Gabriel Canyon in 1891. He and his wife, Jennie, built Fellows Stables, located on Azusa Avenue, where people could catch the stagecoach and sightsee in the San Gabriel Canyon. Follows was killed in an automobile accident near Redlands, California on January 5, 1926.

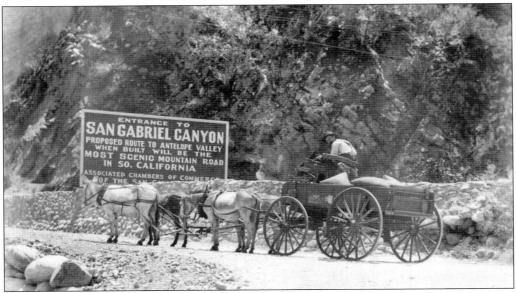

JOHN KNOX PORTWOOD. Known as the "bad man of the canyon," Portwood was an Azusa legend of his time and once boasted of being the toughest man ever to reside in the San Gabriel Canyon., moving there in 1895. It was rumored that he had killed many men in the early days. He was slain in 1920 by a bullet from the firearm of ranger Charlie Nevatney in a spur-of-the-moment dispute.

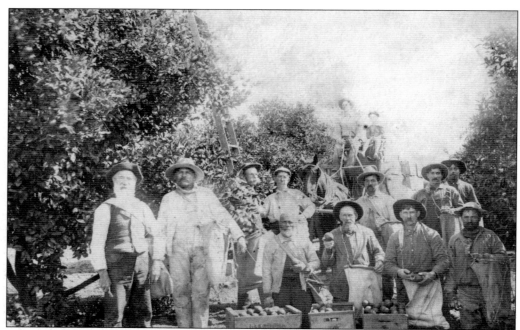

LIFE ON THE AZUSA FOOT-HILL CITRUS RANCH. The foreman, Florencio A. Lopez, is pictured third from left with some fruit pickers. Life on the ranch was not easy. A typical day saw the pickers working from sunrise to dusk filling up their sacks—which weighed an average of 90 pounds when full—and dumping them into crates that would be collected by horse-drawn wagons and taken to the packinghouses for sorting.

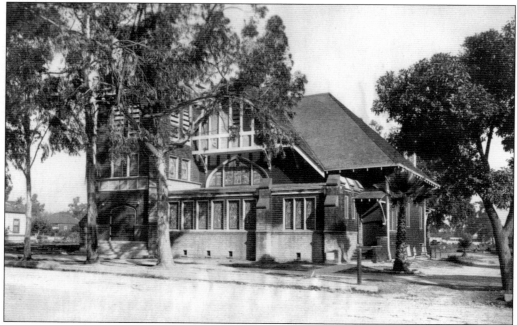

THE "NEW" M. E. CHURCH. Located at 534 North Alameda Avenue, this view shows the final renovations of the M. E. church. It later became the Assembly of God Church.

ALFRED P. GRIFFITH, 1919. Fruit grower and packer Alfred P. Griffith is depicted here on his ranch, known as El Rancho Grande, which was located on the east side of Citrus Avenue.

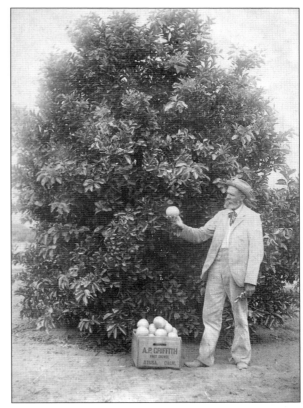

ORTUNO'S POOL HALL. Built in 1910, the pool hall was owned by Anthony Ortuno Sr., seen here at center. Located at 234 North Azusa Avenue, Ortuno's Pool Hall consisted of the billiards tables, a barbershop, and an eatery known as The Beanery.

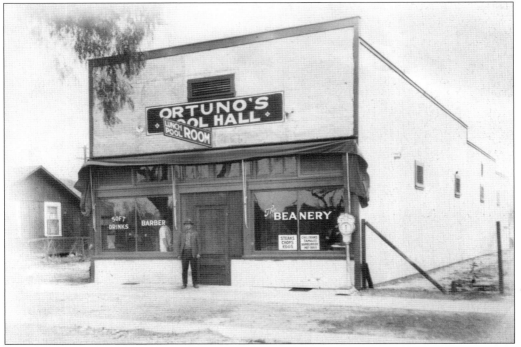

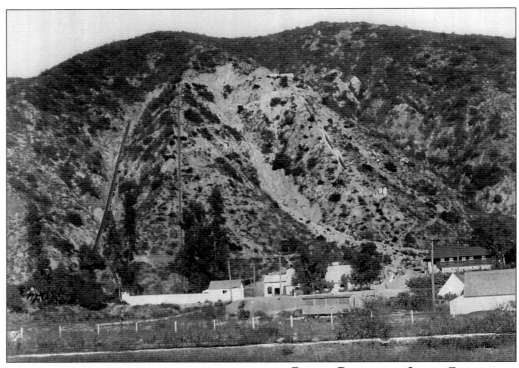

PACIFIC POWER AND LIGHT COMPANY.
The power company was located north of Azusa Avenue on Old San Gabriel Canyon Road, was operated by chief engineer G. O. Newman and later by his son Miller Newman.

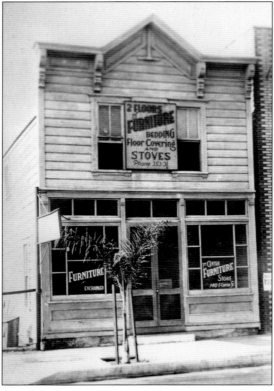

THE CENTER FURNITURE STORE.
Operated by proprietor Sam Winokur, the Center Furniture Store was located at 134 East Center Street (now Foothill Boulevard). This store sold, exchanged, and bought new and second-hand furniture. The Winokurs ran this facility for nearly 50 years.

Three

THE 1920S

The third decade of the century showed a continuous growth in the city, which now had a population of 2,460. Azusans were now realizing the need to preserve their history, and the Azusa Valley Pioneers Society was founded in 1922. The proposition that Paramount Automobile would build a plant in the city brought much excitement, but the plans never materialized. Nonetheless, the city continued to grow, building the Citrus Union High School in 1923 and in 1924 establishing the Azusa Improvement Company, whose charter it was to ensure the betterment of the city. New organizations were established with the introduction of the American Legion post in 1925 and the Rotary Club in 1926. The introduction of Route 66, the new interstate highway, helped advance Azusa's visibility significantly. Growth continued with the building of a new bank facility, a new city hall, and a new woman's club in 1928, closing out the decade with great improvements to the city.

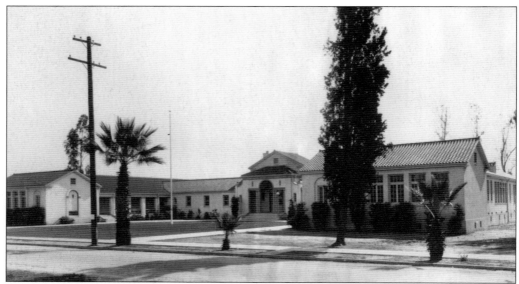

RILEY SCHOOL. Built in 1919 to replace the aged and overcrowded Emerson Public Schoolhouse, this structure was located on Fifth Street between Pasadena Avenue and Soldano Avenue. It was demolished in 1955.

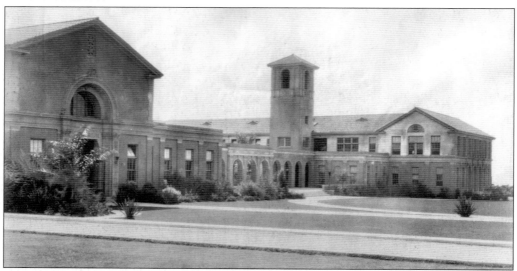

CITRUS UNION HIGH SCHOOL, 1923. The cornerstone of this landmark was laid on June 15, 1922, and formal dedication ceremonies were held on February 23, 1923. The presiding high school board members were president Forrest Manning, clerk J. B. Stair, H. H. Sellers, H. L. Blake, and C. A. Griffith. The old school could no longer house the growing student body. In 1921, the citizens of the district voted $300,000 in bonds for a new school at a new site, centrally located at the southwest corner of Ben Lomand Avenue (Barranca Avenue) and Foothill Boulevard, where the two new beautiful buildings were adorned by artistic entrances and a tower joined by arcades of Spanish renaissance type. The old building on the hill was sold to the Azusa School District, which was formed in 1898, and was renamed Charles H. Lee Intermediate School until it was razed in 1959. Citrus Union High was shared by Azusa and Glendora until 1956, when Azusa High School was built.

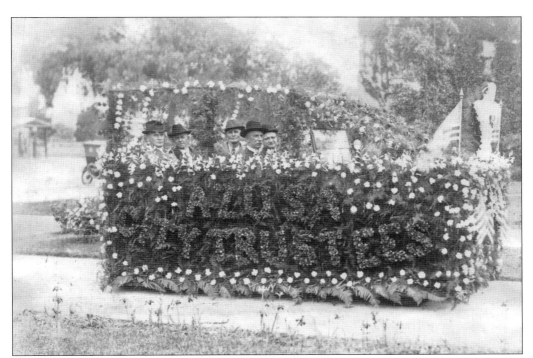

MONROVIA DAY PARADE, 1923. The driver for the Azusa City Council on this day of festivities was Ira Moon; in the front seat is Luther Case and in back, from left to right, are A. L. Meier, Mayor Morgan Pierce, and Howard Chenoweth.

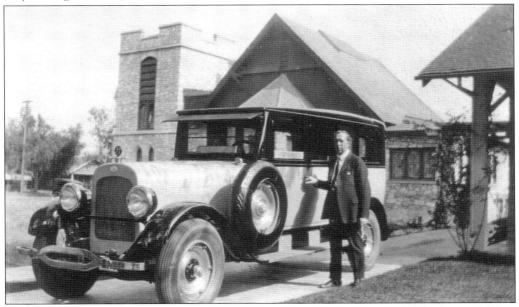

WHITES FUNERAL HOME'S AND DAN B. WHITE AND HEARSE, 1923. Founded by Grace and Dan B. White in 1917, this family-operated mortuary also provided an ambulance service. Originally located at 334 East Center Street (now Foothill Boulevard), the business relocated to their present location in 1924 at 404 Foothill Boulevard.

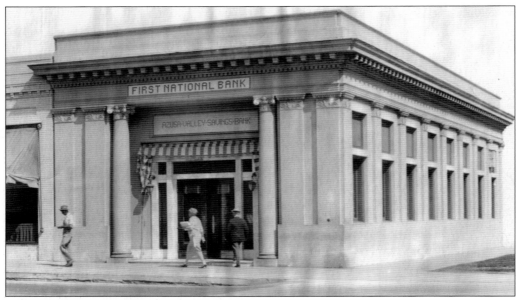

FIRST NATIONAL BANK BUILDING, 1923. Located on the northeast corner of Azusa Avenue and Center Street (now Foothill Boulevard), this building was originally constructed as the United States National Bank in 1906. In 1916, it was sold to the competition, the First National and Azusa Valley Savings Bank, a combine that at the time was located up the street.

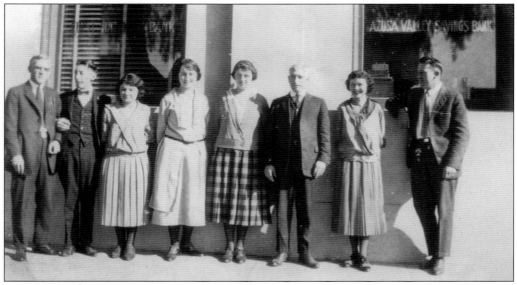

BANK EMPLOYEES. First National Bank of Azusa and Azusa Valley Savings Bank employees are depicted here in 1923. Pictured from left to right, they are Lute Anderson, Donald Edgett, Mabel Wilson, Ruth Laws, Dorothy Sproul, William F. Holden, Gladys Post, and Earl H. Philleo. Philleo started with the bank as a cashier in 1918, working his way up to president in 1938. He retired in 1969 after 51 years of dedicated service.

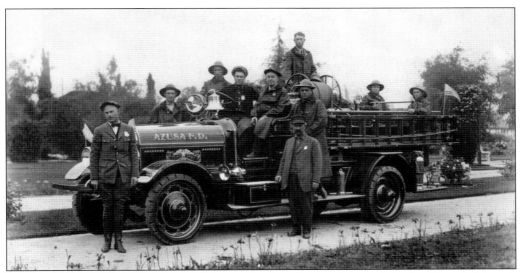

AZUSA FIRE DEPARTMENT TRUCK, 1923. The first fire truck owned by the City of Azusa is seen here. The volunteer firemen no longer had to haul their hose and truck by hand, which occasionally resulted in them arriving too late with too little. Constable Bill Hamblin is in the front center.

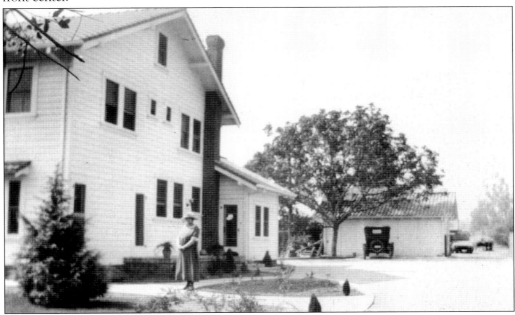

DURRELL RESIDENCE, BUILT IN 1923. Moses Thompson Durrell and his wife, Lillie Delia Thaxter, lived here with their children. Laura Durrell Jones is pictured. The family moved into the house in September 1923. Originally built at 575 East Center Street (now Foothill Boulevard) for an estimated cost of $10,000, the house served the family until 1950, when it was used as a fraternity house for California Polytechnic University, Pomona. In 1987, the youngest daughter of the family, Bernice Durrell, donated it to the City of Azusa. It was moved on December 8, 1987, to its present location at Azusa Veteran's Park, where it has taken on the role of the Museum of the Azusa Historical Society. Its doors opened on September 15, 1991.

PROHIBITION BUST IN 1923. Taken in front of Azusa City Hall on Foothill Boulevard, this photograph depicts the results of a raid. Pictured from left to right are (first row) two unidentified gentlemen, Carl Kimbrell, Steve Saunders, Ernest Mading, William Hamblin, Judge John Durrell, Ed (Sharkey) Gauldin, and another unidentified man; (second row) the only known participants are Bill Davies, second from the left, and Walter Johnson, at far right.

LA AMISTAD GROCERY STORE, 1923. Located at 312 North Soldano Avenue in a residential section of town, this store was originally owned by Raymond Macias Alva until his death in 1935; thereafter, his brother Joe Alva took over.

AZUSA WAR MEMORIAL PLAQUE, 1923.
This is one of two bronze tablets that
were on display at the First National
Bank lobby prior to being mounted
on the base of the War Memorial
Monument. Designed and produced by
E. A. Maloof and Company at a cost
of $850, the plaques bear the names of
soldiers from Azusa who lost their lives
during World War I.

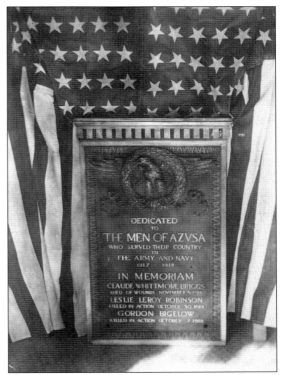

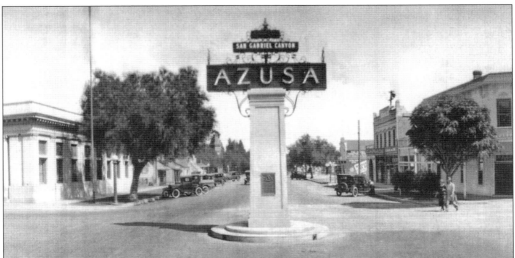

WORLD WAR MEMORIAL, 1923. Completed in September 1923, this distinct monument was located at dead center of the intersection of Azusa Avenue and Center Street (now Foothill Boulevard). It was commissioned by Keith Vosburg, who spearheaded the creation of the monument financed through contributions given by local businesses and private citizen donations. Manuel M. Ruelas was contracted to construct this unique monument in honor of those soldiers from Azusa who lost their lives in World War I. After the idea of a grand ceremony was called off, a simple dedication was done when Ruelas's niece Rose Lopez Noriega was invited to flip the switch that illuminated the top of the structure.

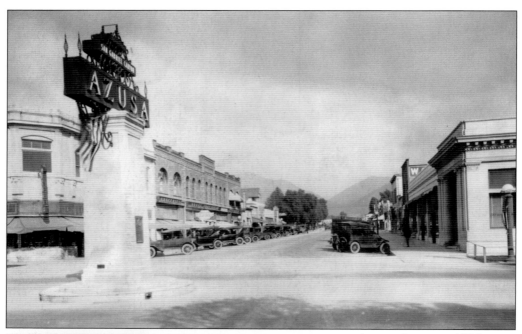

AZUSA AVENUE, 1924.
The avenue is seen in this
northward view toward the
War Memorial Monument.

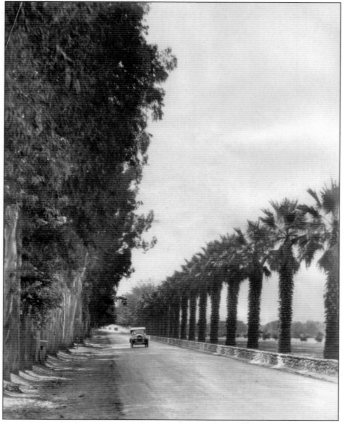

**FOOTHILL BOULEVARD BY
FOOTHILL RANCH, 1923.**
This photograph looks west
along Foothill Boulevard
from Palm Drive.

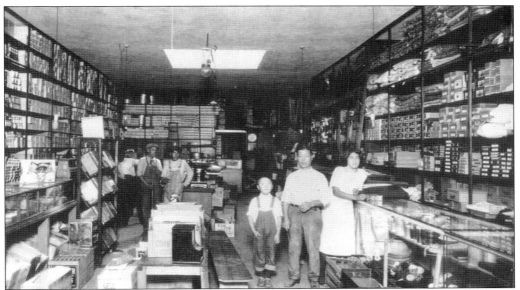

OKI STORE 1923. As far as Azusans were concerned, everything was okay at the O.K. General Merchandise Store, located at 630 North Azusa Avenue. Everything included groceries, hardware, feed, hats, shoes, trunks, suitcases, yardage, lotions, medicine, bullets, guns, watches, and clocks. The store was organized in 1914 by owner Tsuneshiro Oki and was originally located across the street from this location. This same store location was known as the O.K. Style Shoppe from 1946 to 1965.

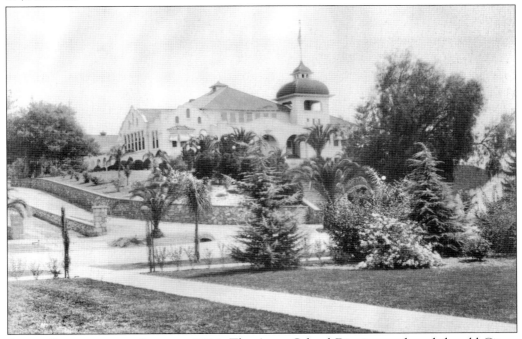

AZUSA INTERMEDIATE SCHOOL, 1924. The Azusa School District purchased the old Citrus Union High School from the Citrus Union High School District and converted it into the Azusa Intermediate School for sixth, seventh, and eighth graders. It's located on Cerritos Avenue.

JOHN OTT AND AVOCADO TREE. This was once the oldest avocado tree in Los Angeles County, planted in 1901. At one time, avocados were referred to as alligator pears and were originally shipped from South America. The tree was located in the 1000 block of Pasadena Avenue.

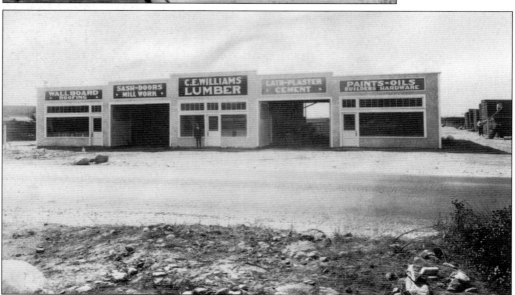

C. E. WILLIAMS LUMBER, 1924. This venerable Azusa business, established in 1924, was once located at 924 West Center Street (Foothill Boulevard). Owned and operated by C. E. Williams, who is pictured in front of his office, the business provided building materials to local contractors, offering everything from foundations to roofs.

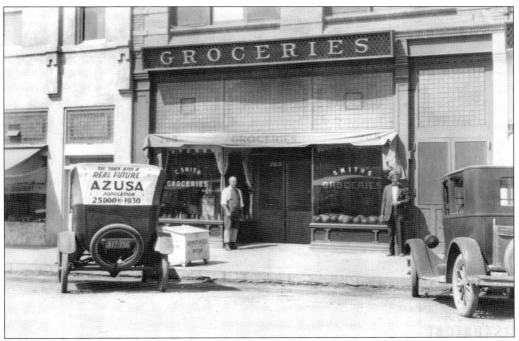

SMITH'S GROCERIES, 1924. Located at 705 North Azusa Avenue was Cornelius Smith's grocery store. Pictured at left, Smith was also the secretary of the Azusa Chamber of Commerce. Note the advertisement on the rear of the automobile at left.

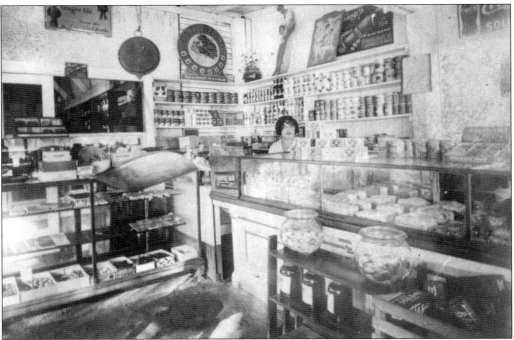

GONZALES GROCERY, 1924. Located at 714 North Azusa Avenue, Gonzales Grocery was also an Azusa mainstay. Seen here is Florence Gonzales, daughter of owner and manager Pete Gonzales.

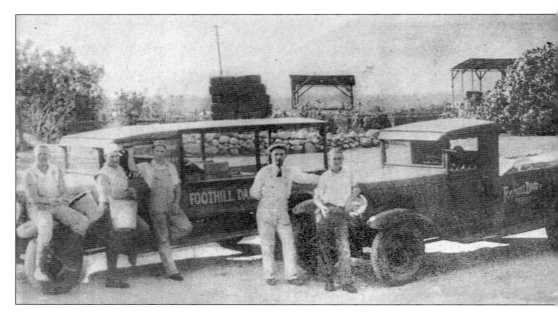

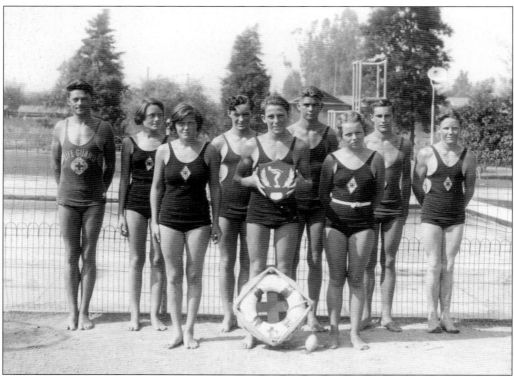

MUNICIPAL SWIMMING POOL. The pool area was officially known as the Slauson Park and Swimming Pool, seen here on the Fourth of July in 1925. The Children of Jonathan Sayre Slauson donated the land and pool to the city of Azusa as a memorial to their father, the founder of the city. The pool was located at the northeast corner of Pasadena Avenue and Fifth Street. The original pool was 40 feet wide by 90 feet long.

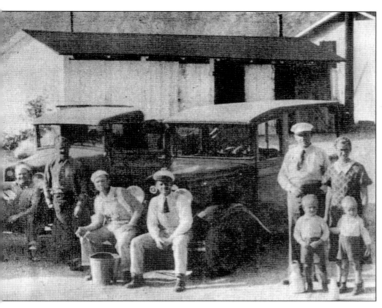

FOOTHILL DAIRY. This business was established in 1924 by William Schlange, who owned and operated the facility. Once located at 8145 San Gabriel Canyon Road, it was known for its award-winning milk and dairy products. This photograph shows the entire staff and management alongside their delivery trucks. The Schlange family can be seen at right.

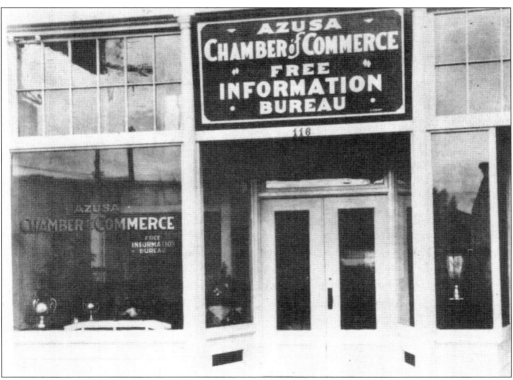

AZUSA CHAMBER OF COMMERCE OFFICE. The Azusa Improvement Club formed in 1893 with C. C. Casey as its first president, aiming to "provide means for advancing the public interests of the town and vicinity." It evolved into the Azusa Chamber of Commerce, which held its first official meeting on August 5, 1895, with a membership of 21 local businessmen, each paying $5. This photograph was taken at 116 Center Street (now Foothill Boulevard).

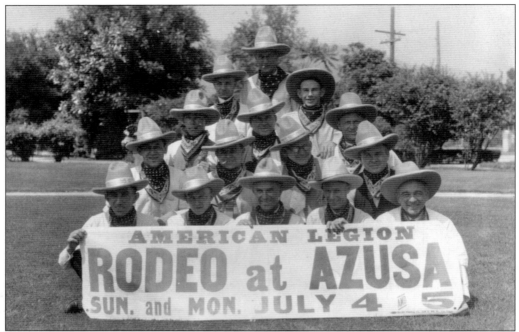

AMERICAN LEGION RODEO, JULY 1926. Canyon City Post 180 was organized on February 18, 1926. The photograph shows a large portion of the members of the Azusa Legion. The Azusa American Legion Rodeo was a very successful event that was attended by many throughout the state. It was short-lived due to the Great Depression.

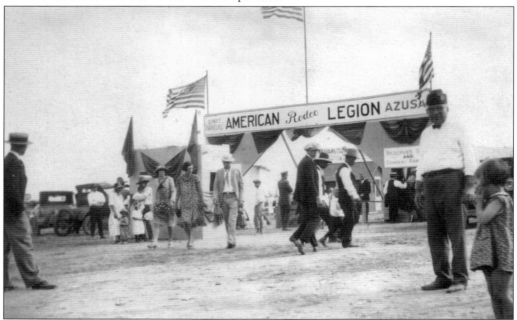

LASSOES AND BRONCOS. Rodeos were a very popular diversion in California throughout the 20th century and have influences dating back to the Mexican vaqueros and the American cowboys. Here is a look at the entrance of the Azusa American Legion Rodeo held on July 4, 1926.

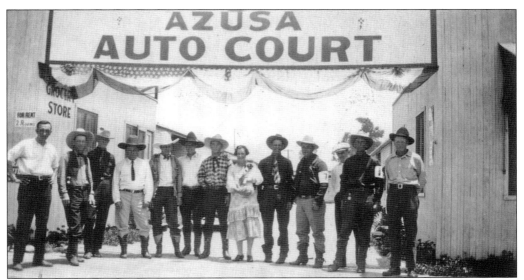

AZUSA AUTO COURT, JULY 4, 1927. Once located at 538 North Dalton Avenue, the Azusa Auto Court was a popular destination for overnight guests in the 1920s. Pictured here is a group of cowboys in town for the annual American Legion Rodeo. Mrs. C. F. Fridley, who operated the facility, is in the center of the photograph.

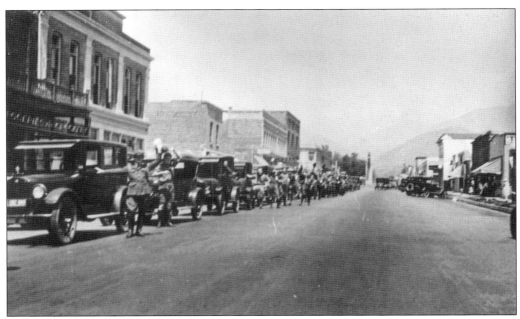

BOY SCOUT TROOP. The Azusa Boy Scouts, with scoutmaster Keith Vosburg, are pictured on their way to the San Gabriel Canyon for a weekend trip in 1926. This view looks north from Azusa Avenue toward Foothill Boulevard. Vosburg was very active in the Boy Scout organization, sponsoring various trips to Catalina Island.

PARISH HALL. Located on the northeast corner of Dalton Avenue and Fourth Street, Parish Hall was built in 1926 by parishioners of St. Frances of Rome Church under the direction of Anthony Ortuno Sr. and Manuel M. Ruelas. The exterior was produced from a cement-block machine loaned by Ventura Torres. The hall has been used for wedding receptions, catechetical classes, fiestas, and other parish activities.

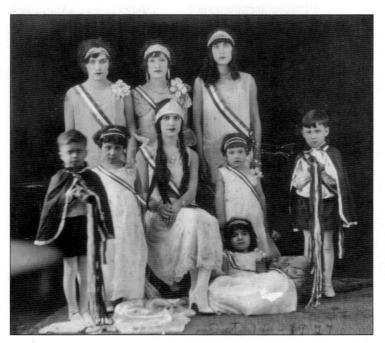

QUEEN AND COURT. This photograph was taken on September 16, 1927. The tradition of crowning a queen and her court began in the 1910s to celebrate the independence of Mexico from Spanish rule after the revolution that began on September 16, 1810. The Azusa parade concluded with a large fiesta. Seen here is queen Julia Alva (center). The boy at right is Fernando Rubio. In the back, from left to right, are princesses Anita Macias, Josie Nunez, and Mary Ceja.

AZUSA THEATRE.
The dedication of the theatre was held on December 30, 1927, after being built by realty brokers Vosburg Brothers Inc. The theatre hosted the world premier showing of *A Texas Steer,* starring Will Rogers. Azusa Theatres and Principal Theatre, Inc., were located on the northeast corner of Azusa Avenue and Sixth Street.

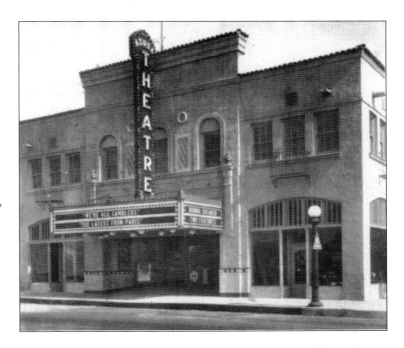

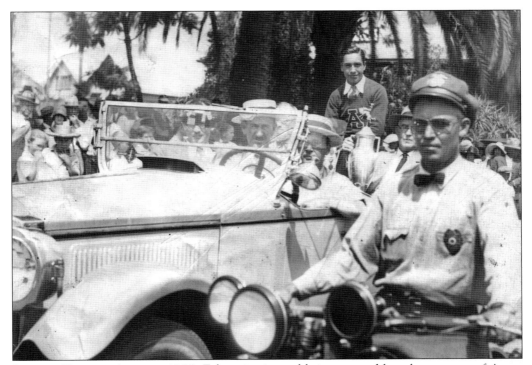

JOHNNY FALCON, AUGUST 1928. Falcon is pictured being greeted by a large group of Azusa residents who held a parade in his honor upon his return from the Junior Olympics held in Atlantic City. Falcon, age 14, won the basketball throw, making 19 out of 20 baskets. His trip was sponsored by the Azusa City Council and the Azusa Rotary Club.

AZUSA CLINIC. On August 10, 1928, this image was taken in honor of clinic's 10th anniversary. It was located at 160 North Azusa Avenue, founded and financed by Kate Slauson Vosburg (right) and run by superintendent and nurse Alpha Marcum.

GROUP PHOTOGRAPH OF AZUSA CLINIC. The staff, management, and patients of the Azusa Clinic are pictured on August 10, 1928. Identified in the photograph are clinic founder Kate Vosburg (far right), Alpha Marcum (to her left), and Mabel Chilberg (far left). Chilberg was Vosburg's personal assistant.

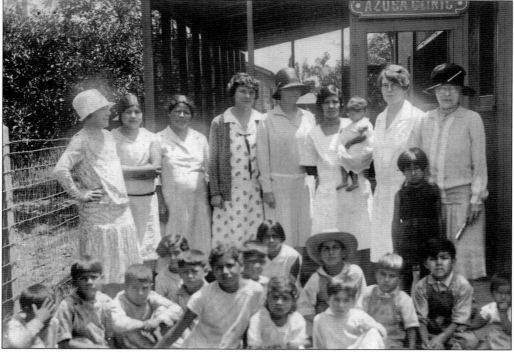

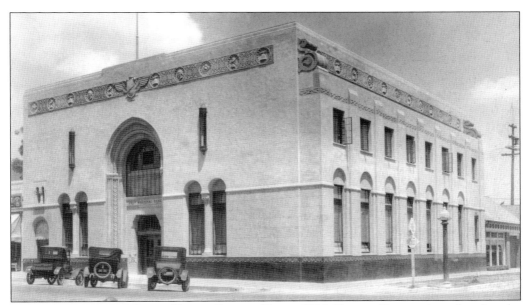

First National and Azusa Valley Savings Bank, 1928. Designed by prominent Los Angeles architect Robert H. Orr and constructed under the direction of project superintendent S. A. Johnson of Los Angeles–based contractors McKee Brothers, this two-story Spanish Moorish–style building is located at 700 North Azusa Avenue. The second floor housed the ACG Fruit Exchange, city attorneys Thashner and Miller, the YMCA offices, and the office of noted author Alec Watkins. After 40 more years of continuous service, both banks liquidated their holdings in 1968 and sold to Wells Fargo Bank.

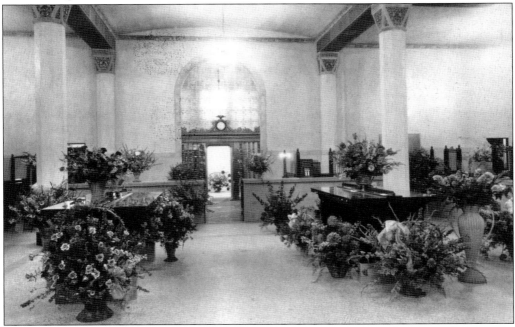

Bank Interior. This photograph shows the lobby of First National and Azusa Valley Savings Bank on the night of the official opening of its new facility on August 11, 1928.

NEW CITY HALL. Built in 1928, the Andrew Carnegie Grant Library became the center of the Azusa City Hall Civic Center. Designed by architect Robert Bates, the 400-seat auditorium was constructed on the east side, forming the east wing. The Azusa City Hall offices were built on

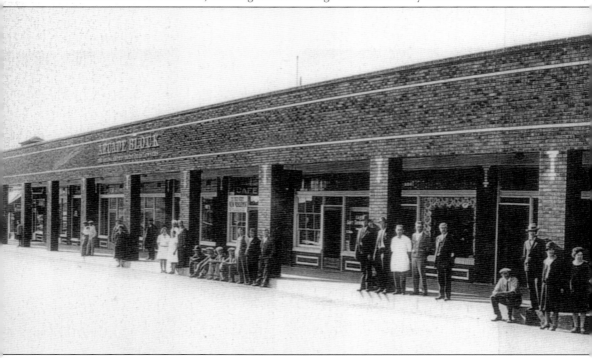

ARCADE BLOCK, 1928. Built on the former site of the old Azusa Hotel, the Arcade Block was a project of the Azusa Improvement Company, which was organized in 1924 by a representative group

the west side, forming the west wing. The complex was built in the Spanish style, with a red tile roofs, at a cost of $60,000 and is located on Foothill Boulevard between Alameda Avenue and Dalton Avenue.

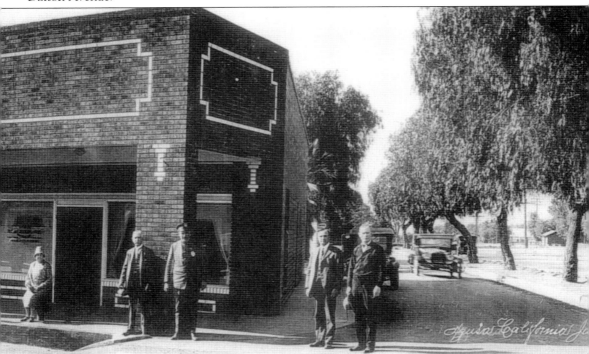

of Azusa citizens and business owners. The Arcade was located on the southwest corner of Azusa Avenue and Santa Fe Street. The modern brick structure came with a price tag of $50,000.

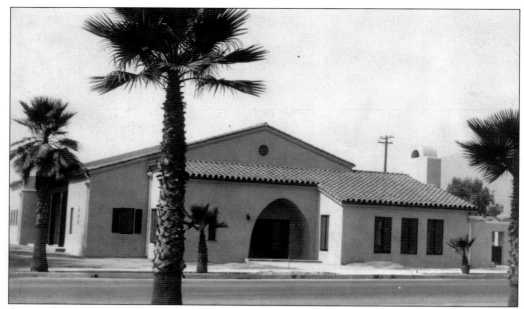

AZUSA WOMEN'S CLUB CLUBHOUSE, 1928. Located at 1003 North Azusa Avenue, this structure with Spanish-style stucco and tile roof was designed by noted Los Angeles architect Robert H. Orr and built at a cost of $30,000 by Azusa contractor Charles Mace. Kate Slauson Vosburg (who was not a member of the club) generously gave $10,000 toward the interest on the loan for the new facility. In appreciation of her philanthropy, the membership voted Vosburg an honorary lifetime member.

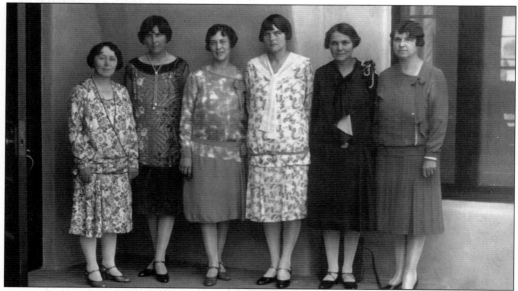

WOMEN'S CLUB BOARD OF DIRECTORS, 1928. The first club meeting in the new clubhouse was held on October 3, 1928. Pictured from left to right are Mrs. Lute F. Anderson, first vice president; Mrs. R. S. Woods, program chairman; Mrs. W. G. Wheatley, president; Mrs. C. C. Carpenter, corresponding secretary; Mrs. George Garrett, recording secretary; and Mrs. Verne Heth, treasurer.

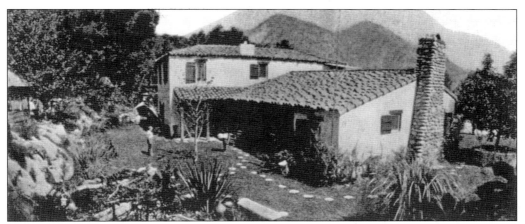

EL ENCANTO "NEWMAN'S RESIDENCE." Named El Encanto, meaning "the enchanted," this residence was built by Henrietta Roberts and Miller Newman in 1920 as their home and "Camp One" for the use of the U.S. Forest Service. Miller Newman was a U.S. Forest Service ranger for the San Gabriel Canyon. Henrietta was born in Azusa in 1881 and was the daughter of Susana Melendrez and Henry C. Roberts. In the 1930s, Henrietta started catering private parties in her home and soon became well known for her delicious dishes. The restaurant was later added to the front of their residence, and a liquor license was obtained in March 1939.

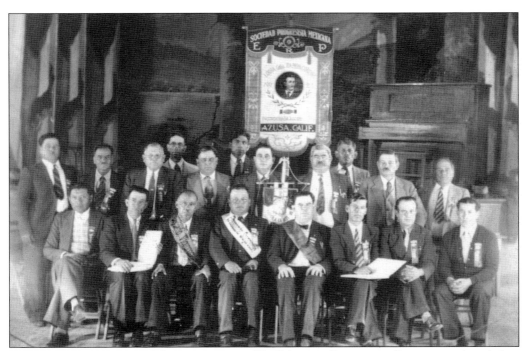

SOCIEDAD PROGROSIESTA MEXICANA, 1929. The Mexican Progressive Society was founded in Bakersfield, California and incorporated on October 16, 1929. This fraternal organization was not a political or religious group but was formed to promote education, respect, and patriotism through out the Mexican community. The Ramon Corona Lodge, or Lodge 23, of the society was organized at Azusa on November 17, 1929.

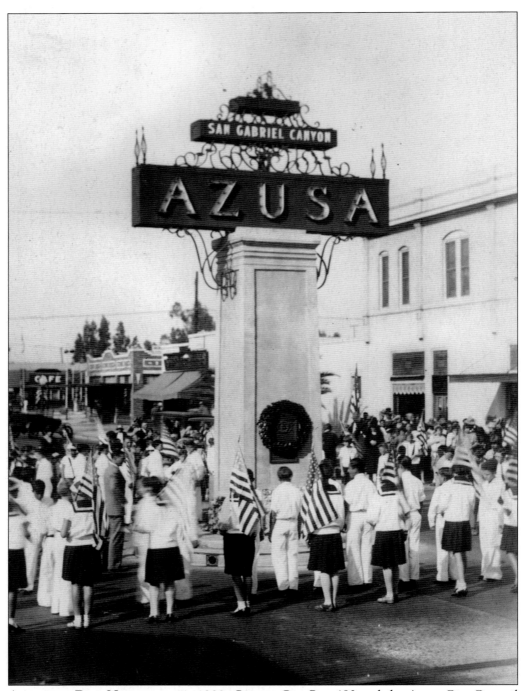

ARMISTICE DAY, NOVEMBER 11, 1929. Canyon City Post 180 and the Azusa City Council hosted the annual Armistice Day parade, which proceeded along Foothill Boulevard and commenced at the War Memorial Monument. The Azusa Boy Scouts acted as honor guards, students from the Azusa City School District performed, and the Citrus Union High School band and student body expressed their patriotism.

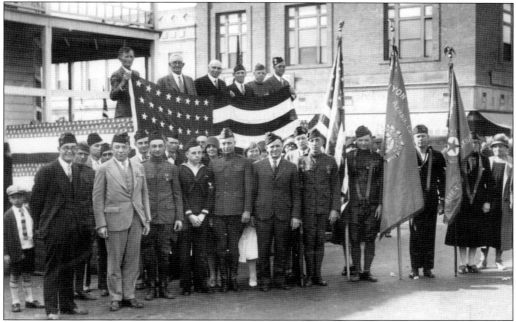

WORLD WAR I VETERANS, NOVEMBER 11, 1929. This photograph showing the members of Canyon City Post No. 180 of the American Legion was taken in front of the Brunges Hotel at the Armistice Day Ceremonies in a celebration honoring those Azusan army and navy veterans who fought in "The Great War."

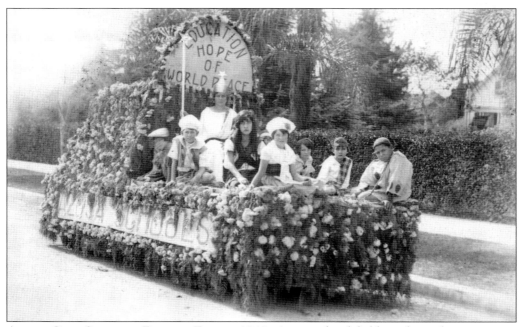

AZUSA CITY SCHOOLS PARADE FLOAT, 1919. Azusa schoolchildren dressed in costumes representing different cultures of the world are pictured on Armistice Day in the Azusa Schools float, "Education: Hope of World Peace."

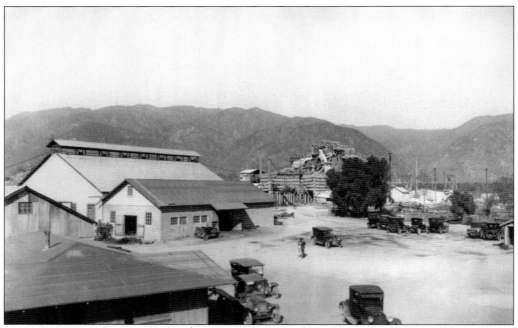

PUENTE LARGO PLANT OF UNION ROCK COMPANY. This gravel pit, considered to be one of the finest deposits of gravel, rock, and sand in the world, was once located on the east bank of San Gabriel River, north of Foothill Boulevard, extending west to what is now Todd Avenue. The rock and sand industry has added much to the economy of Azusa.

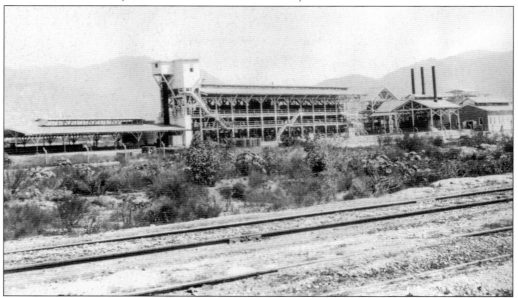

OWL FUMIGATING COMPANY. This Azusa company used the basic principal of fumigation consisting of confining and killing insects infesting trees with a high concentration of deadly hydrocyanic acid gas under tents. The concept remains the same today as it was when it was first demonstrated to be the most practical method of killing bugs in citrus groves. In 1935, this facility was renamed American Cianamid.

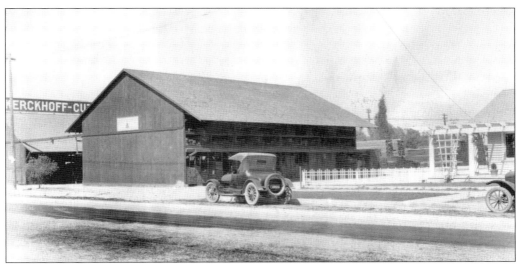

KERCKOFF AND CUZNER MILLWORK AND LUMBER COMPANY. This lumber company was in existence prior to the city's founding and thus earned the nickname "Old Standby." Once located at Foothill Boulevard and Angeleno Avenue, this business was managed by George Garrett for many years.

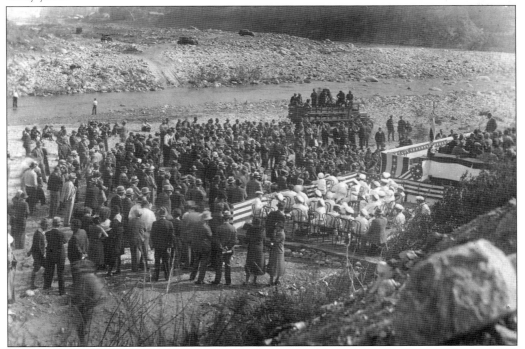

FORMAL DEDICATION OF SAN GABRIEL DAM NO. 1. Building of this dam required over 2,000 men throughout the region and was part of a $25-million flood-control project. The dam was to sit 425 feet above the riverbed and would require 4,228,000 cubic yards of mass concrete. Unfortunately, after the project had begun, seismic findings indicated that an earthquake fault ran too close and posed a potential danger. As a result, construction of this dam was abandoned in 1929.

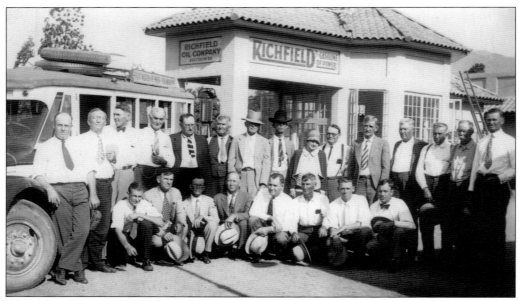

RICHFIELD GASOLINE AND OIL STATION, 1929. Once located on Foothill Boulevard, this was Station No. 54 of the Richfield Gasoline and Oil Station chain. Seen here in the center of the photograph, first row, fifth from left, if George Ott, who managed the facility for many years and was known for his quality customer service and kind personality.

AZUSA CHAMBER OF COMMERCE DISPLAY, 1920s. An annual competition at the Los Angeles County Fairgrounds in Pomona allowed communities in the county to compete against each other. This photograph shows the Azusa Chamber of Commerce entry, which received an award for best display.

Four

THE 1930S AND 1940S

Although depression hit the rest of the country, it failed to have a great effect on Azusa. This was evident in the establishment of clubs like the Rainbow Angling Club (in 1930), whose goal it was to create a place of peace and serenity for those who enjoyed trout fishing. Construction of the Morris Dam brought jobs to the area when employment was at an all-time low, and Azusa celebrated its 50th golden jubilee in 1937. The dam took the spotlight again in 1938 when torrential rain threatened collapse of the dam and forced the evacuation of many of the city's residents.

The 1940s and the advent of World War II brought great changes to Azusa, which in 1940 held a population of 5,209. The war meant rationing and the draft, as many of the city's young men were called into action. The city faced its first blackout on December 18, 1941, and established the Defense Center in March 1942. In April 1942, Bob Hope was named honorary mayor of Azusa to a crowd of 400 at an event sponsored by the Azusa Red Cross.

But the war was not the only focus. What was once a vibrant citrus culture was destroyed by the introduction of the tree disease known as "quick decline," discovered on the Foot-Hill Ranch in 1940. As a result, the city's agricultural economy was replaced with business from companies like Aerojet Corporation, Wynn's Oil Products, Electroweld Steel, El Sereno Machine, and Lucky Lager Brewing Company. With industrial growth came smog and pollutants. Early 1946 marked the beginning of what was to become several years of residential construction in Azusa. Most of the remaining orange groves fell to the onslaught of the bulldozer and became great tracts of low- and medium-priced homes. As industries were established and homes built, there was a heavy influx of people to the city, and by 1947 the population had increased to 8,506. In 1948, Anthony M. Ortono, the first Mexican American councilman, was named into office. New organizations were established in Azusa during this time, including the Veterans of Foreign Wars, the Eagles Lodge, and the Elks Lodge.

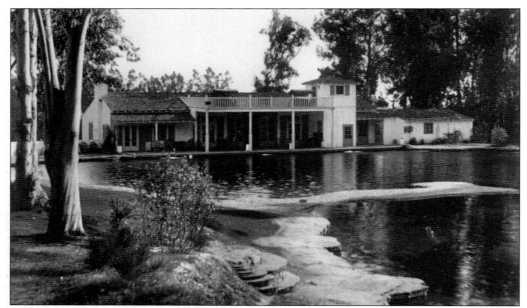

RAINBOW ANGLING CLUB, 1930. Construction began in 1929 at the east end of Tenth Street and Pasadena Avenue. With a grand opening in March 1920, the Rainbow Angling Club offered peace and serenity for those who enjoyed fishing for trout. It was owned and operated by a Mr. Garnsey. The lake was located on the former site of the Azusa Ice Manufacturing Plant.

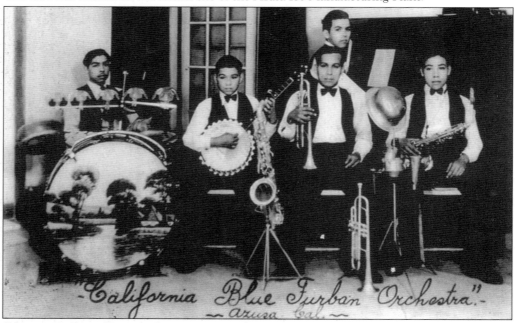

CALIFORNIA BLUE TURBAN ORCHESTRA, 1930. Consisting mostly of brothers, this popular group of young men performed for private parties and special occasions. Over the years, the band grew and eventually changed its name to the Johnny Luna Orchestra. Pictured from left to right are Joe Lopez (drums), Andrew Luna (banjo), Johnny Luna (horn), Arthur Sanchez (piano), and Leno Luna (saxophone).

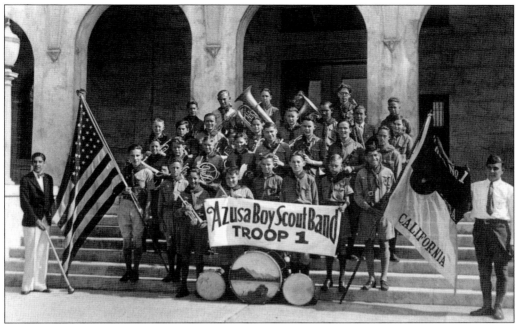

AZUSA BOY SCOUT BAND TROOP NO. 1. This 1930 photograph was taken in front of the Azusa Public Library. The band director is Freddy De Silva.

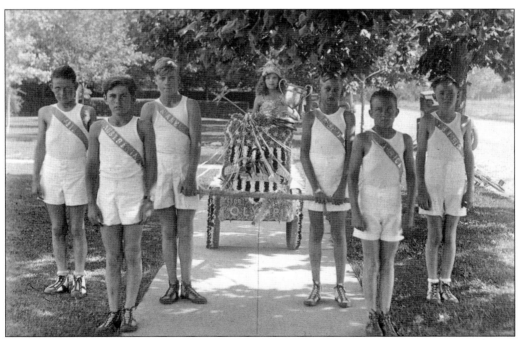

1932 OLYMPIC PARADE ENTRY. The parade was held in Ocean Park, California, and this photograph was taken in front of a home located at 1023 North Soldano Avenue. Representing Azusa from left to right are Paul Brecht, Bill Day, Wallace Corkhill, Meredith Durrell, Jack Williams, Bud Kamerdiener, and Garland Williams.

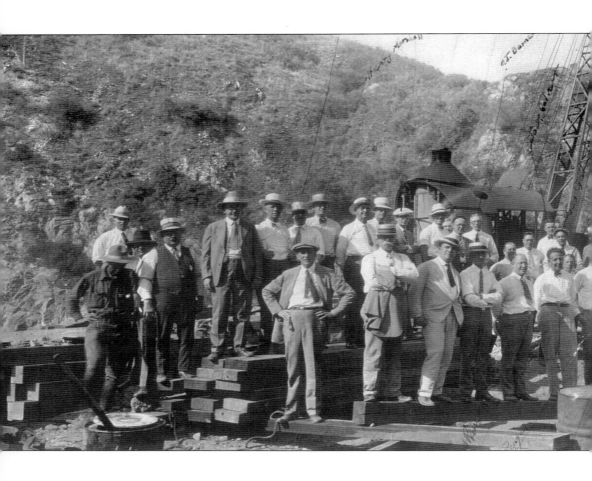

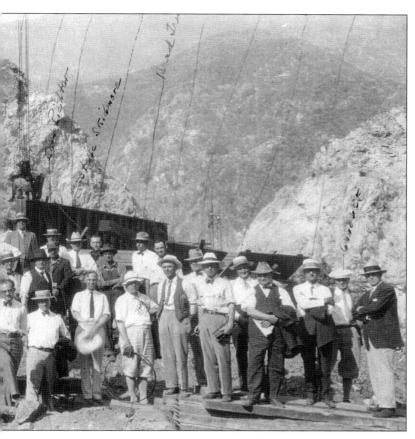

MORRIS DAM NO. 1 GROUND-BREAKING CEREMONY, 1932. The Morris Dam was completed and then dedicated in 1934. Originally named the Pasadena Dam, The Metropolitan Water District used the dam for storage from 1941 to 1977, at which time it was turned over to the Los Angeles County Flood Control District.

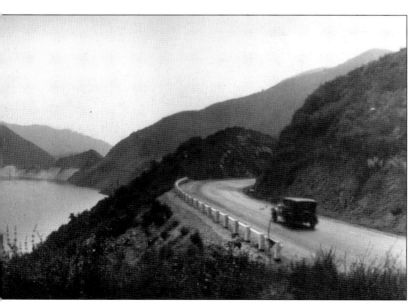

SAN GABRIEL CANYON, 1930. This panoramic view of the San Gabriel Mountains and River in the canyon shows the Morris Dam in the background. Known for its scenic drive and beautiful views, the canyon helped Azusa earn the title of "The Canyon City."

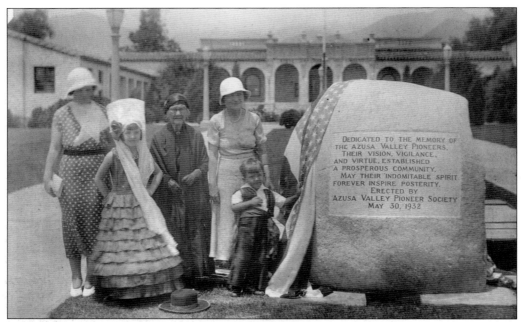

AZUSA VALLEY PIONEER SOCIETY BOULDER, 1932. Formed at the suggestion of Emma De Shields Inman, whose family came to Azusa in a covered wagon and planted the first orange grove in the valley, the Azusa Valley Pioneer Society consisted of pioneer residents from Azusa, Glendora, Covina, and neighboring communities. The group first met on May 30, 1921, in a blue gum grove located on the Azusa Foot-Hill Citrus Company Ranch. This grove was later turned over to the city and converted into a recreational area now known as Laura D. Jones Pioneer Park. Pictured at the dedication of the society's boulder, from left to right are Henrietta Newman, Margaret Peterson, Susanna Melendrez Roberts, Nora Peterson, and Bill Stevens.

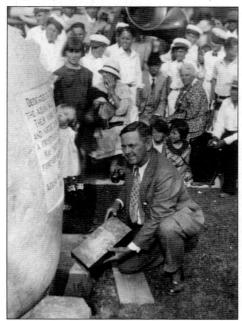

D. A. BEARDSLEE. On May 30, 1932, a boulder from the San Gabriel River was dedicated and unveiled in the Azusa Civic Center Park. The event was commemorated by speeches given by noted author and historian John Steven McGroarty; Roger Dalton, great-grandson of Henry Dalton; and Edward Robertson, president of the AVP Society. The chairman of the program, D. A. Beardslee (pictured), deposited a copper time capsule containing newspapers of the valley and other historical relics.

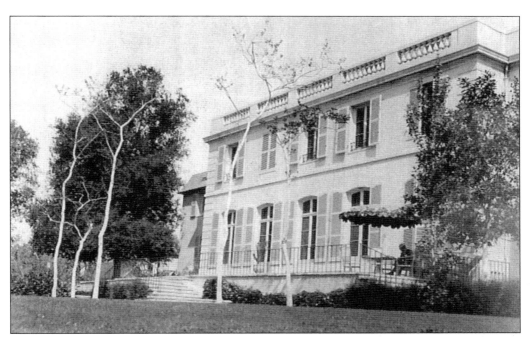

MACNEIL ESTATE. Completed on September 25, 1932, by C. F. Marlow and designed by noted architect Robert David Farquhar, this elaborate two-story mansion built on 6.5 acres was the home for Louise Slauson Macneil. On May 2, 1947, Macneil sold the property to the Jesuits, who turned it into the Manresa Retreat House and moved to the Huntington Hotel in Pasadena, California. The only stipulation upon sale was that her funeral services be held at the house upon her passing. Louise Macneil passed away on February 18, 1949, and her wishes were granted.

CITRUS AVENUE, 1932. Looking north on Citrus Avenue just south of Alosta Avenue, Edith A. Bowers Orange Grove is to the right of photograph, and the May Badger Grove with the Azusa Foothill Citrus Company Orange Groves are to the left.

WOMANLESS WEDDING. This play, which ran to sold-out crowds on December 7 and December 9, 1932, at the Azusa City Auditorium, was sponsored by the Azusa Chamber of Commerce and performed by an all-male cast made up of some of the most prominent men in Azusa, including the mayor, council members, and the bank president. The director was Bulamac Sympon from Bardstown, Kentucky.

AZUSA INTERMEDIATE SCHOOL NAME CHANGE, 1936. The school was renamed Charles H. Lee Intermediate School in honor of his six years of service on the high school board and his 24 years on the elementary school board. Pictured here at the dedication ceremony, from left to right, are Charles H. Lee, William Goedart, Paul Smith, and Jack Taylor. Lee's granddaughter is in the foreground.

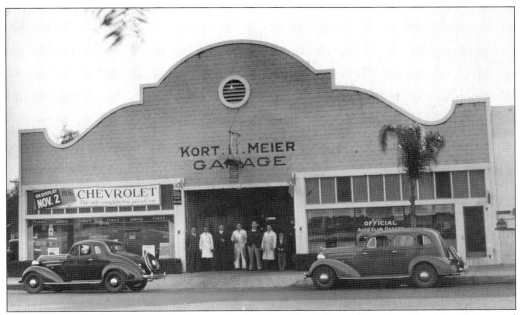

KORT H. MEIER GARAGE, 1936. Located at 250 East Foothill Boulevard and built in the second decade of the 20th century with a mission-style facade by Ralph and Ira Moon, this structure was originally known as the Azusa Garage. Kort H. Meier later occupied the garage.

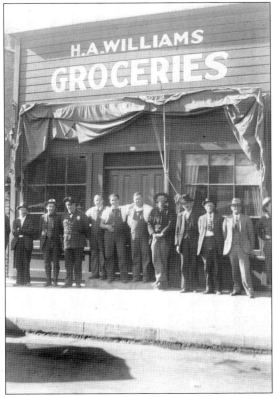

H. A. WILLIAMS GROCERIES. The second building to be constructed in the newly founded Azusa was the grocery store at 717 North Azusa Avenue. It was erected in 1887 with the help of Ed Thompson hauling the lumber from the Santa Fe depot. H. A. Williams, the leading civic–spirited Azusan in the first days of the city, bought the store in the spring of 1888 from J. C. Whitney, who had started it in the fall of 1887. This photograph was taken just before it was demolished and replaced by a modern building. Pictured from left to right are W. I. Rury, Irving D. Carter, Miller Newman, Ed Gauldin, Hank Williams, Louis Williams, Fred Williams, Jim Ruddell, William Peters, Pen Barnes, A. S. Coulson, and Frank West. It was the second-oldest grocery in Southern California when it closed on November 14, 1936.

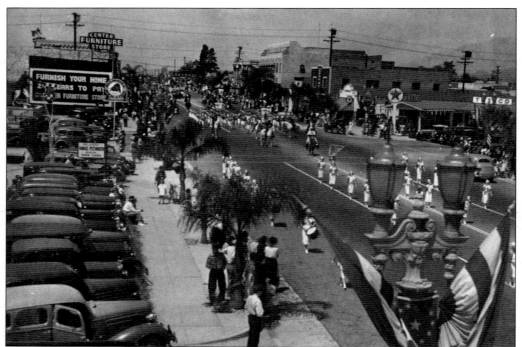

AZUSA GOLDEN JUBILEE 50TH ANNIVERSARY CELEBRATION, 1937. This celebration was held on May 1, 1937, in honor of the 50th anniversary of the founding of the city of Azusa. A parade went down Foothill Boulevard with the honored guest and dignitaries seated in front of city hall. Everything from antique autos to the original Rancho Azusa bell was part of the festivities.

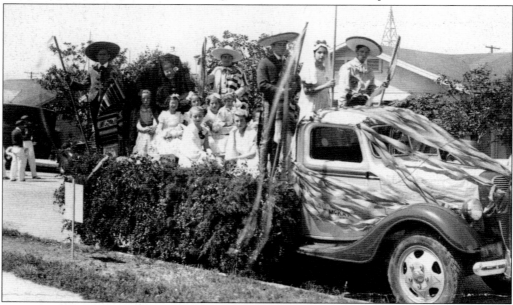

AZUSA GOLDEN JUBILEE QUEEN'S FLOAT, 1937. Mrs. Luisa Hutchison, the daughter of one of Henry Dalton's ranch foreman, was chosen to be queen of the Golden Jubilee celebration. Here she is with her court on their float, ready to ride down Foothill Boulevard.

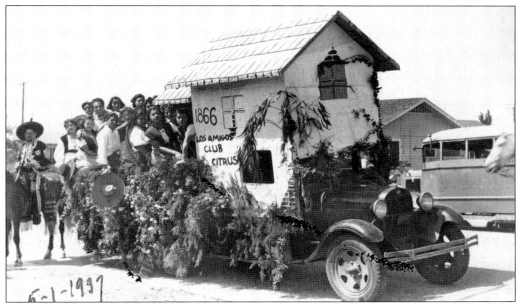

AZUSA GOLDEN JUBILEE. The Citrus Union High School's Los Amigos Club float rolls by during the Golden Jubilee on May 1, 1937. The Los Amigos Spanish Club promoted friendship among its members through school programs featuring dancing, singing, and authentic Mexican costumes.

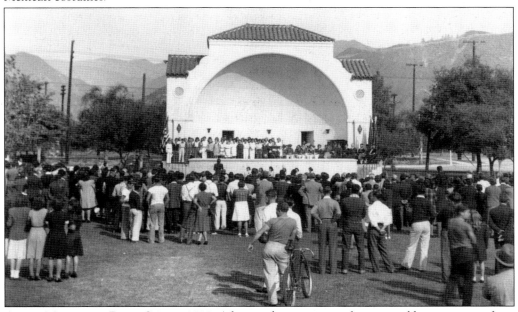

AZUSA MUNICIPAL BAND SHELL, 1939. After much anticipation for a central location to perform and meet, the Azusa Municipal Band Shell was built in the spring of 1939. Once located behind the Azusa Public Library, it was the site of many events and performances. The grand dedication took place on May 27, 1939, at 8:00 p.m., with performances by the Citrus Union High School Band, an a cappella choir, novelty acts, and solo performances. There was dancing on the tennis courts with music from Bill Potter's orchestra.

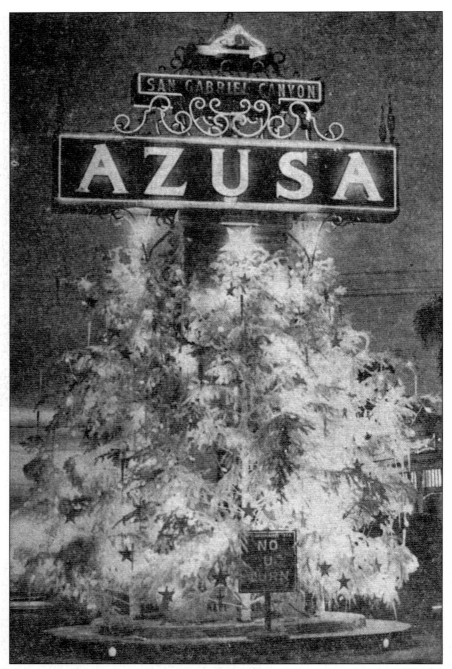

WAR MEMORIAL MONUMENT, CHRISTMAS 1932. Since its construction in 1923, the Azusa Chamber of Commerce, in an effort to promote the holiday season, was responsible for decorating the base of the War Memorial Monument. The tradition continued until the removal of the monument in 1946.

AZUSA CIVIC CENTER CHRISTMAS TREE, 1939. A tradition that started in 1916 with simple decorations applied to a young tree, the annul ceremony usually took place with Santa Claus illuminating the lights and later meeting with the local children.

BANK OF AMERICA, 1940. Located at 152 East Foothill Boulevard, this building was constructed from 1939 to February 1940 for the Bank of America National Trust and Savings Association, which moved into the structure in March 1940. M. G. Davis served as manager, and Otto Zippwald Jr. was assistant cashier.

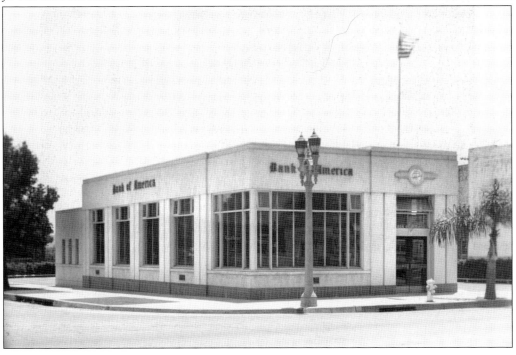

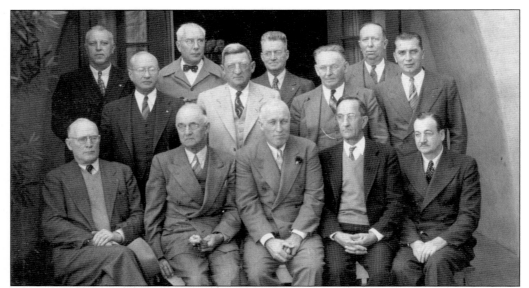

Azusa Rotary Club Past Presidents, 1940. Pictured here are (first row) A. L. Meier, T. F. Heth, W. A. Johnson, P. S. Tscharner, and Frank Allen; (second row) Ray Hulbert, C. A. Griffith, Gordon W. Wheatley, and C. C. Carpenter; (back row) E. H. Philleo, A. H. Miller, Leland S. Poage, and Dan B. White. The Azusa Rotary Club was chartered on February 8, 1927.

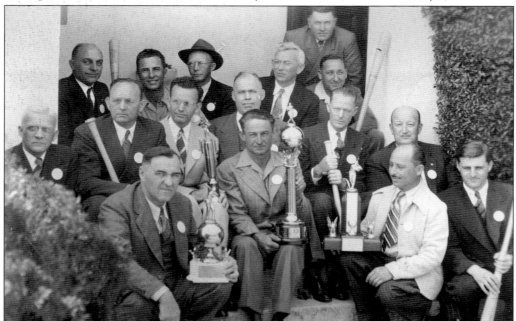

Azusa Civitan Club, 1941. Pictured here from left to right are (first row) Cliff Rucker, Cecil Singleton, George Smith and Rev. Winston Trevor; (second row) L. F. Anderson, Leo Ebersold, William L. Alsup, Ralph H. Pryor, Charlie Nichols, and Louis G. Memmesheimer; (third row) Herman E. Bakenhus, Thomas Sharp, Roy Phillips, Edwin C. Snyder, and Cecil Hibsch; (fourth row) E. E. Jones. The Azusa Civitan Club officially became a member of the international organization on February 19, 1938.

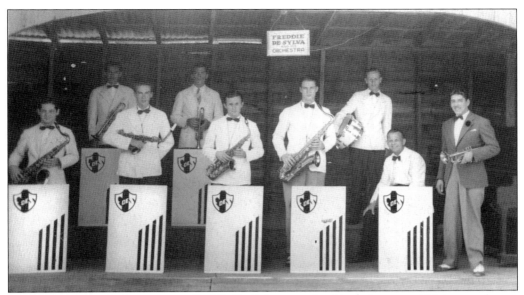

FREDDIE DE SYLVA'S ORCHESTRA. Freddie De Sylva was a local boy who started his own orchestra during the swing era of the 1940s and was a hit at the local concerts and events. This photograph was taken on July 13, 1941.

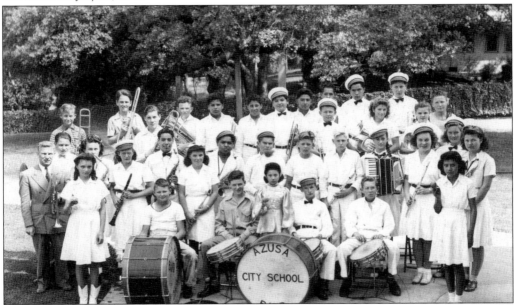

AZUSA CITY SCHOOL BAND. Pictured here from left to right on May 6, 1943, at the Charles H. Lee Intermediate School, are (first row) Betty Shomber, Larry Hemmel, Danny Beach, Gloria Gonzales, Roger Dunn, Jim Cook, and Ruth Ramos; (second row) Ralph Schrock, Director Marion Taylor, Betty Cooper, Lillian Goedert, Joe Vallin, Louise Zerell, Tony Torres, Howard Hummel, Buddy Menedenhall, Gunter Schlange, Doreen Middleton, Georgia Rodecker, Connie Overley, and Ealine Shaffer; (third row) Allan Hibsch, Malcolm Lee, Mac Short, Dick Snyder, Johnny Montoya, Fred Ortiz, Raymond Sarinana, Povfie Sandoval, Robert Schrock, Modesto Leon, Conception Cruz, Shirley Cole, Dan Engle, Meredith Mendenhall, and James Cobb.

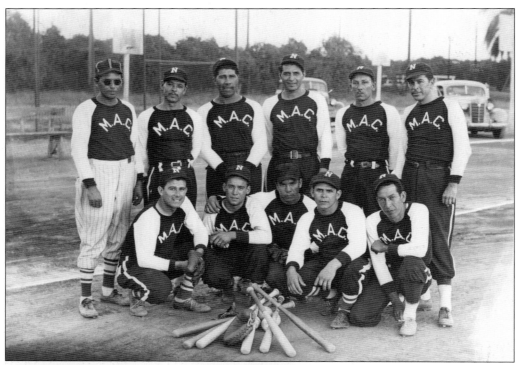

MEXICAN AMERICAN CLUB, 1945.
The Mexican American Club
was sponsored by Abdelnour's
Store. The team won the 1945
Azusa Youth Program Softball
Tournament, which was held at
the Charles H. Lee Intermediate
School. Pictured here from left to
right are (first row) Tony Garcia,
Saul Rodriguez, unidentified, Leno
Friajo, and Joe De Avalos; (second
row) Marcos Elias, Raymond Lujan,
unidentified, Robert Ayon Sr., Tony
Contreras, and Mathew Mariscal.

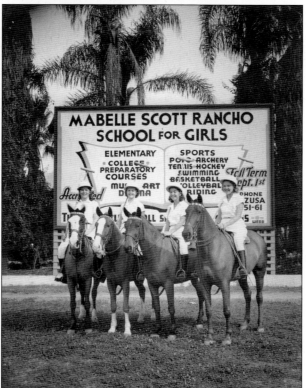

MABELLE SCOTT RANCHO SCHOOL
FOR GIRLS. Originally known as
the Orange Grove School when it
opened in 1926, this institution was
later called the Fulton School for
Girls. Eventually it was purchased
by Mabelle Scott, who opened the
Mabelle Scott Rancho School for
Girls, an elite accredited school for
girls from elementary-school ages
up to college-preparation ages.

AZUSA HERALD NEWSPAPER. Founded by publisher and horticulturist John W. Jeffrey on October 20, 1887, this hometown newspaper was published each Thursday. The August 16, 1945, edition printed the cheerful news of the end of World War II. It also posted the final list of those in the armed services whose lives were lost.

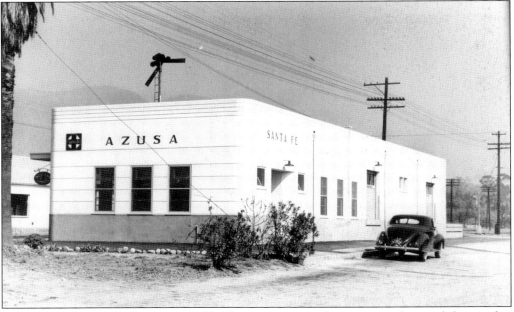

REMODELED SANTA FE STATION, 1946. These concrete walls were erected around the wooden shell of the original Santa Fe Railroad Building. Done in the modern style, the remodeled station's construction was halted during World War II and completed soon after the war ended.

JACK BENNY, JANUARY 1946. Honorary mayor Jack Benny accepts the key to the city of Azusa in January 1946. The radio and film star was named honorary mayor for the recognition he brought to the cities of Azusa, Cucamonga, Anaheim via his popular radio show's fictitious railroad conductor (played by Mel Blanc), who on January 7, 1945, first hollered, "All aboard for Anaheim, Azusa, and Cuuuc . . . amonga!" It made the three cities recognizable to Benny fans across the country. Pictured from left to right are E. W. Moller, City of Anaheim secretary and manager of the Anaheim Chamber of Commerce; Jack Benny; Cornelius Smith, Azusa Chamber of Commerce secretary; and Clifton Charrell, Cucamonga Service Club chairman.

LEO C. NASSER MEN'S CLOTHING STORE, 1946. Originally built for H. A. Greene as the Azusa Market, this building located at 706 North Azusa Avenue became an Alpha Beta Market until 1939 when the *Azusa Herald* newspaper purchased the site and remodeled the facade in art deco style. In 1945, Leo C. Nasser purchased the location and relocated his men's clothing store there. Nasser's was known for high quality clothing and superior customer service.

AEROJET GENERAL CORPORATION, 1946. A subsidiary of General Tire and Rubber Company, Aerojet had offices in Azusa, Sacramento, and Cincinnati. Founded by Dr. Theodore Von Karman, Aerojet was the navy's largest contractor for torpedoes. They also conducted research and produced a wide range of products.

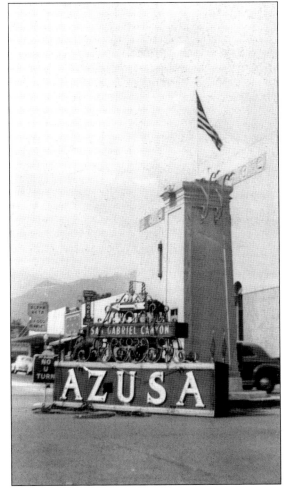

AZUSA WORLD WAR I MONUMENT DEMOLISHED, 1946. A unanimous vote of the city council on July 12, 1946, concluded that the World War Monument was a traffic hazard at the intersection of Azusa Avenue and Foothill Boulevard. The monument was ordered demolished. A replica was erected on the lawn of Azusa City Hall in August 1947.

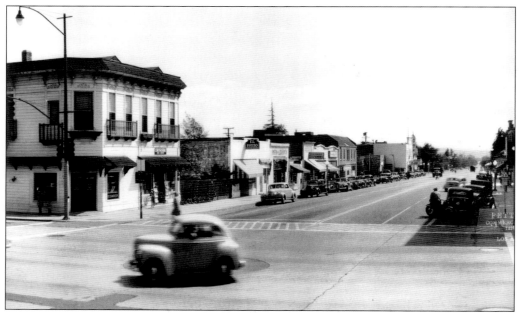

DOWNTOWN VIEW OF AZUSA AVENUE, 1946. Looking southeast toward the 600 block of Azusa Avenue, this view shows the Brunges Hotel and the El Patio Mexican Restaurant.

LUCKY LAGER BREWING COMPANY, 1948. The Lucky Lager Brewing Company Tower was a nine-story building visible from all points of the San Gabriel Valley and functioned as a unit of one of the largest brewing operations in California. The slogan for the age-dated beer was, "It's Lucky when you live in California."

Five

THE MODERNIZATION
OF AZUSA

The 1940s closed off with the first Azusa Golden Days celebration, held on October 29, 1949. It was a citywide celebration of the California Gold Rush centennial, spearheaded by the committee's general chairman, Leo C. Nasser. Over 25,000 spectators from all over the valley arrived and witnessed what had been called the "greatest pioneer celebration." With Sheriff Eugene Biscailuz as grand marshal, the event included such notables such as Stuart Hamblen and Montie Montana. The parade along Foothill Boulevard concluded with a barbecue and the dedication of Memorial Park done in memory of the 29 Azusa boys who had lost their lives in World War II.

The Korean War began in 1950. The 1950 census showed a population of 11,042 in the city, a significant increase from the past. As a result, it was faced with a need to build up its foundational structures for the improvement of the community. In 1952, Paramount Elementary School was built. In 1954, the census showed that the population had increased to 15, 087. As a result, Dalton Elementary School was built, followed by Mountain View Elementary and Pioneer Park in 1955. Valleydale, Drendel, and Ellington Elementary Schools were opened in 1956, as was Azusa High School. The year 1957 saw the opening of three more elementary schools with Powell, Magnolia, and Longfellow. Gladstone Street and Foothill Elementary followed in 1958 with the ground-breaking ceremony for the new St. Frances of Rome Church. The new Azusa Public Library was dedicated in April 1959. In the spring of 1959, a group of Azusa voters petitioned the county committee on school organization. The Azusa City School District and the Gladstone School District formed to a unified district, with the responsibility of educating pupils from kindergarten through 12th grade.

The 1950s also boasted a number of firsts for the city, including the appointment of the first Mexican American policeman, Edward Alvarez; the first female councilperson, Martha Johnson; and the first female police officer, Marjorie "Pinkey" Hunter.

A study done by the Azusa Chamber of Commerce in April 1959 revealed that the city had passed out of the agricultural age and into the industrial. In 1959, there were 136 industries in Azusa, producing motorized doodlebugs, boats, mobile homes, millwork, foundries, beer, chemicals and many others. By 1960, the population was 20,685.

SLAUSON SCHOOL. Named in honor of Azusa founder Jonathan Sayre Slauson, this school is located at 340 West Fifth Street. Built to replace the original 1920s facility that was small and outdated, this building opened its doors on September 14, 1948.

SNOWFALL IN AZUSA, JANUARY 1949. While the city of Azusa rests at the foot of the San Gabriel Mountains, which receive annual snowfalls, it's very rare when the lower San Gabriel River Valley sees any of the white precipitation. In 1949, snow did fall in Azusa.

MEMORIAL PARK, 1949. Community volunteers, city employees, and service clubs built this park in one day. Cement and building materials were donated by local merchants.

MEMORIAL PARK, 1949. Musical entertainment kept the children occupied while the grown-ups worked. Here on the xylophone from left to right, are Patty Jones, Marsh Jones (her father), and Marsha Jones.

GROUND-BREAKING FOR ARMORY, 1949. Major General Hudleston and Louis Memmesheimer of the Azusa City Council were at the January 23, 1949, ground-breaking ceremony for the California National Guard Building located on Orange Avenue.

FIRST AZUSA GOLDEN DAYS, 1949. This is a preplanning session of Azusa Golden Days on October 10, 1949. Seen here from left to right are community chest representative Floyd S. Hayden, chamber of commerce vice president Carl Wright, VFW candidate for Queen of Azusa's Golden Day's Patty Jones, actor Robert Ryan, Civitan candidate Shirley Hertenstein, city councilman Leo C. Nasser, Mayor Harry D. Jumper, and March of Dimes chairman Cornelius Smith.

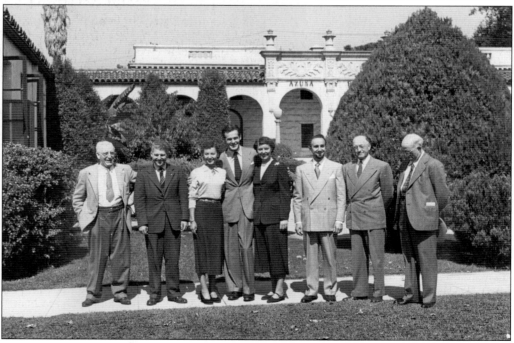

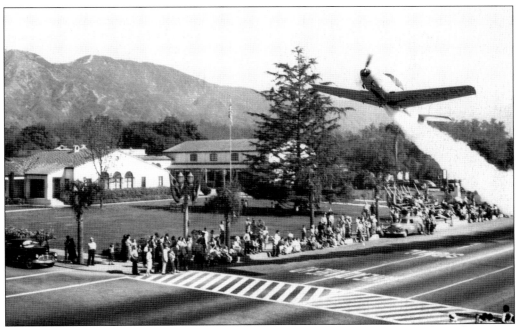

MORE AZUSA GOLDEN DAYS PARADE, 1949. Aerojet's parade demonstration of a Jato Rocket's power over the parade route was witnessed by more than 25,000 spectators from all over the San Gabriel Valley.

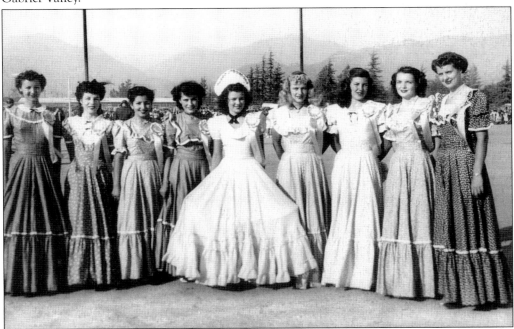

FIRST AZUSA GOLDEN DAYS QUEEN AND PRINCESSES. Pictured here from left to right, on October 29, 1949, are Patty Jones, Marie Moronez, Rosie Vasquez, Delia Chaidez, Queen Nancy Murphy, Joann Meeder, Jean Shores, Betty Shomber, and Shirley Hertenstein. This event evolved into the Miss Azusa Pageant.

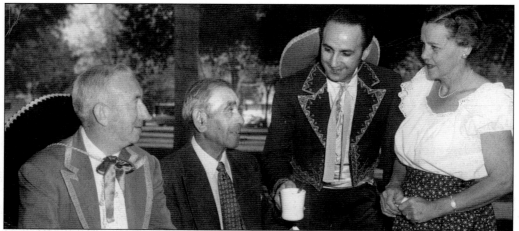

MANUEL RUELAS HONORED. The first honored citizen of Azusa Golden Days in 1949 was Manuel M. Ruelas. Born in Azusa on June 5, 1880, he was known as a native old-timer. He was again bestowed the title of honored citizen in 1953. This photograph shows a breakfast held in his honor before the 1953 parade. Pictured from left to right are Harry J. Adams, chairman of the 1953 Golden Days parade; Manuel M. Ruelas; Leo C. Nasser, Azusa Golden Days general chairman; and Mrs. Petway Conn, president of the Azusa Women's Club.

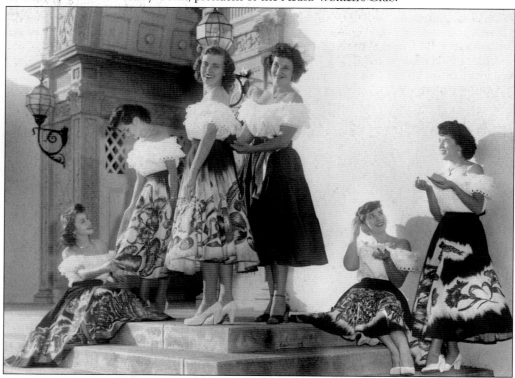

AZUSA GOLDEN DAYS, 1953. The queen and her princesses are being fitted with their Mexican costumes for the Azusa Golden Days parade. Seen from left to right are Eleanor Marlin, Annie Dominguez, Queen Betty Ana Perry, Jane Paul, Charlene Sanders, and Lillian Maruffo. The parade's theme that year was "A Little Spanish Town."

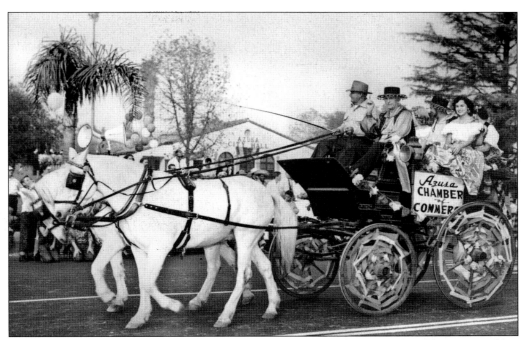

AZUSA CHAMBER OF COMMERCE ENTRY. The event the chamber entered is the Azusa Golden Days parade of 1953. In the front seat with the driver is Cornelius Smith, secretary of the Azusa Chamber of Commerce. In the back seat, from left to right, are Mary Ann Warner, chamber president Clifton Wynn, and Vera Maruffo.

AZUSA VALLEY PIONEER SOCIETY MEETING, 1954. Although membership in the society would dwindle throughout the years, those remaining believed it to be worthwhile and continued to meet in the park located behind the Azusa Public Library. In 1964, at the recommendation of Donell M. Spencer, the Pioneer Society was transformed into the Azusa Historical Society, thereby ensuring that the work and efforts of the organization would continue into the future.

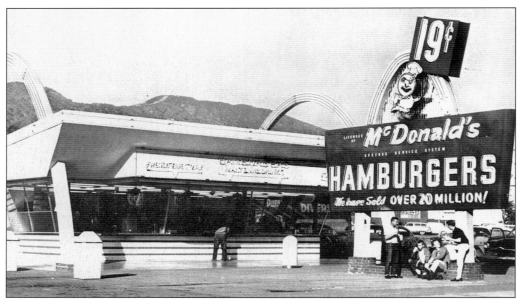

MCDONALD'S RESTAURANT, 1954. Once located at the Azusa Square Shopping Center on Foothill Boulevard, this eighth in the chain of McDonald's opened to the public on September 17, 1954. Jack R. Widmeyer of San Bernardino owned it and Dave Duffy was the original manager. The self-service system was the brainchild of brothers Richard and Maurice McDonald, who were the sons of Patrick and Margaret McDonald of 502½ North Azusa Avenue. The family moved to Azusa from Manchester, New Hampshire, in 1932. Duffy termed the Azusa McDonald's as "the best of food, at reasonable prices" with 15¢ hamburgers and 10¢ French fries. This location closed in 1984.

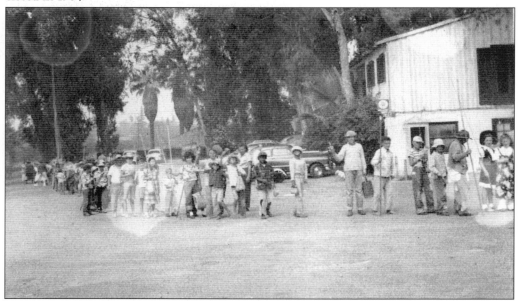

HUCK FINN DAY. The 1954 event was held at the Rainbow Angling Club. Sponsored by the Azusa Rotary Club, each of the youngsters was allowed to catch four trout and eat all the watermelon possible.

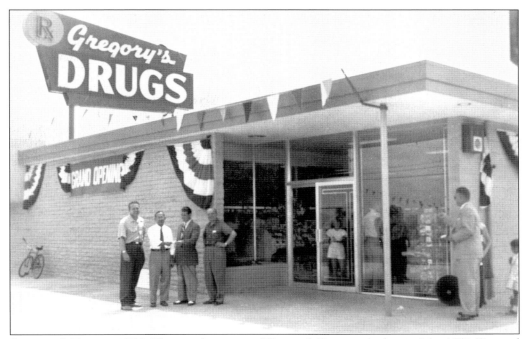

GREGORY'S DRUGS, 1954. The grand opening of Gregory's Drugs took place in May 1954. Pictured from left to right in front of the store at 103 South Azusa Avenue are Al Groski; Charles B. McLees, president of the Azusa Chamber of Commerce; Gene Groski; and owner Richard A. Gouze.

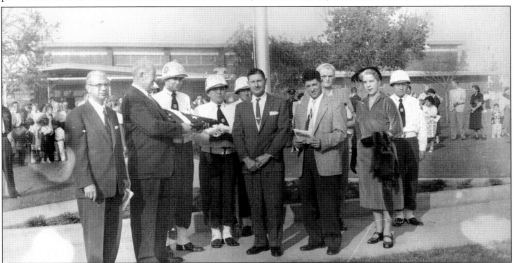

RECREATION BUILDING DEDICATION. On November 20, 1955, the United States flag and the California state flag were presented to Mayor Memmesheimer and other members of the Azusa City Council by the Veterans of Foreign Wars. Seen here from left to right are (first row) Rev. B. J. Paroulek, member of recreation committee; Mayor Memmesheimer; councilman Clarence H. Fawcett; councilman Cecil Romero; and councilwoman Martha M. Johnson. Located at Memorial Park at 320 North Orange Place, it was built at a cost of $170,000. Construction commenced in February 1955. Benjamin S. Parker was the architect, and Maggie Boyer was the recreation building manager.

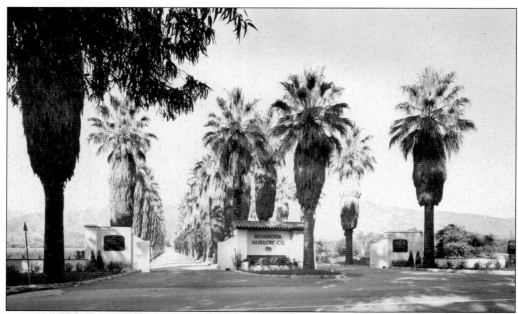

MONROVIA NURSERY, 1955. In 1954, Harry Rosedale, founder and owner of the Monrovia Nursery Company, erected authentic California-style gates at the double-drive entrance to the nursery. The redwood gates were mounted on white and red brick monument signs and posts. The gate united the two ranchos, Alisal and Cacomites, for the first time. Since their construction, the gates, posts, and monument sign have been considered a local landmark and have remained in their original form, serving as a symbol for the company and gracing the cover of nearly every sales catalog since 1955.

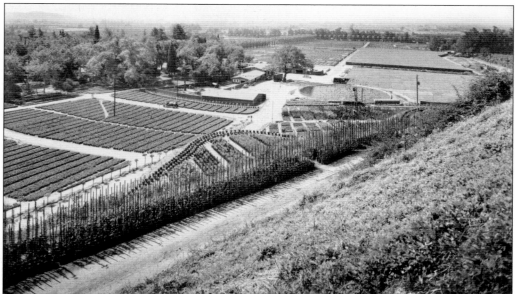

AERIAL VIEW OF MONROVIA NURSERY PROPERTY, 1956. This view of "the world's largest container-grown plant nursery" faces south above Bougainvillea Hill toward Palm Drive. Visible in the photograph are the Monrovia Nursery Company's garages and water reservoir.

FOOTHILL SHOPPING CENTER, 1956. The formal ground-breaking for the Foothill Shopping Center took place on January 5, 1956. Seen here from left to right are Hugh Macneil, president of the Azusa Foothill Citrus Company; Mrs. Sayre Macneil, owner of the property and Hugh's mother; Antonio Moreno, actor; James D. Macneil, Azusa Foothill Citrus Company vice president; C. L. Peck Jr., contractor; Milton L. Anderson, architect; C. L. Peck, contractor; and William Beck, representative of Mayfair Market, the first unit in the shopping center.

FOOTHILL SHOPPING CENTER COMPLETION, 1956. Built at the cost of $5 million on 23 acres at the southwest corner of Citrus and Alosta Avenues, the center was constructed for 21 stores to lease at the site.

AZUSA HIGH SCHOOL, 1956. With an enrollment of 1,050 pupils—all of them sophomores and freshmen, Azusa High School opened its doors in September 1956 under the direction of former Citrus Union High School principal Dr. Nelson C. Price. The student body had the responsibility of choosing their new school mascot (the Aztecs) and the school colors (turquoise, black, and white). Designed by the Neptune architectural firm, the facility cost $1,435,000 (plus an additional $200,000 for equipment) and was formally dedicated on November 12, 1957, during a ceremony conducted by Dr. J. W. Hankins, president of the school board of trustees.

AZUSA AMERICAN LITTLE LEAGUE. The baseball league was sponsored by the Azusa Recreation Department in 1955. Over 250 children attended tryouts, and opening day was May 5, 1956.

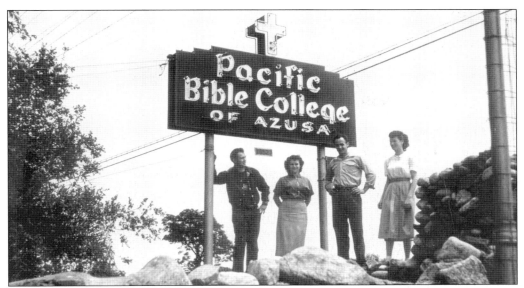

PACIFIC BIBLE COLLEGE OF AZUSA, 1955. Founded in 1899 in Whittier, California, as the Training School for Christian Workers, the school had four other locations before settling in Azusa in 1946 on the 12-acre site of the former Mabelle Scott Rancho School for Girls. Classes began in the fall of 1947. The school had several name changes throughout the years, changing to Azusa College in 1956, then to Azusa Pacific College after its merger with the Los Angeles Pacific College in 1965. After achieving university status in 1981, it was renamed to Azusa Pacific University, as it is known today.

GROUND-BREAKING OF AZUSA PUBLIC LIBRARY, 1958. Ground-breaking ceremonies for the New Azusa Public Library took place on April 15, 1958. Pictured from left to right are city administrator James Miller, councilwomen Martha M. Johnson, councilman Clarence H. Fawcett, building contractor Herman Rempel, Mayor Louis Memmesheimer, head librarian Gladys Alexander, library board trustee V. Gilbert Ross, building architect Benjamin S. Parker, library board trustee Lillian V. Trujillo, Mrs. Kimble, and councilman Cecil Romero.

ACROSS AMERICA, PEOPLE ARE DISCOVERING SOMETHING WONDERFUL. *THEIR HERITAGE.*

Arcadia Publishing is the leading local history publisher in the United States. With more than 3,000 titles in print and hundreds of new titles released every year, Arcadia has extensive specialized experience chronicling the history of communities and celebrating America's hidden stories, bringing to life the people, places, and events from the past. To discover the history of other communities across the nation, please visit:

www.arcadiapublishing.com

Customized search tools allow you to find regional history books about the town where you grew up, the cities where your friends and family live, the town where your parents met, or even that retirement spot you've been dreaming about.